Photography by
EAMONN McCABE

Written by
MICHAEL McNAY

ARTISTS
AND THEIR
STUDIOS

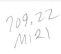

Published by Angela Patchell Books Ltd
www.angelapatchellbooks.com

registered address
36 Victoria Road, Dartmouth
Devon, TQ6 9SB

contact sales and editorial
sales@angelapatchellbooks.com or
angie@angelapatchellbooks.com

copyright APB 2008

All rights reserved. No part of this publication maybe reproduced, stored in a
retrieval system or transmitted in any form or by any means, electronic, mechanical,
photocopying, downloaded, recordings or otherwise, without the permission of the
copyright holder.

The publisher, editor and authors accept no responsibility in respect of information given
or referred to or for any errors, omissions, mis-statements or mistakes of any kind.

ISBN: 978-1-906245-06-1

Book design by Toby Matthews
Photography by Eamonn McCabe

Front cover and contents page: Antony Gormley and his studio.
Title page: Duncan Grant's studio in the Charleston Farmhouse, near Lewes.

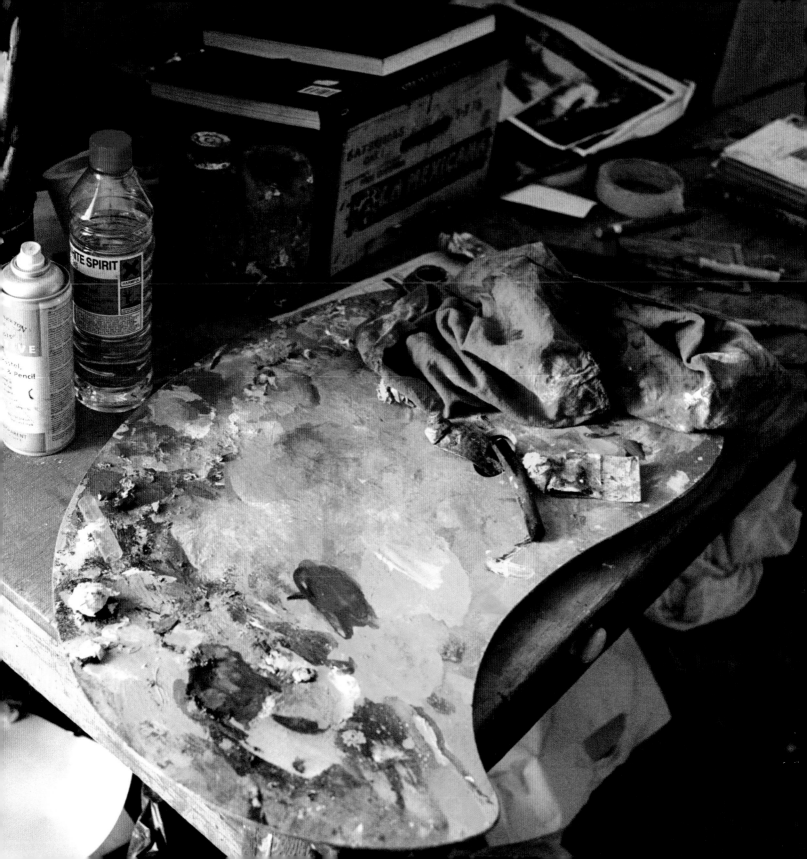

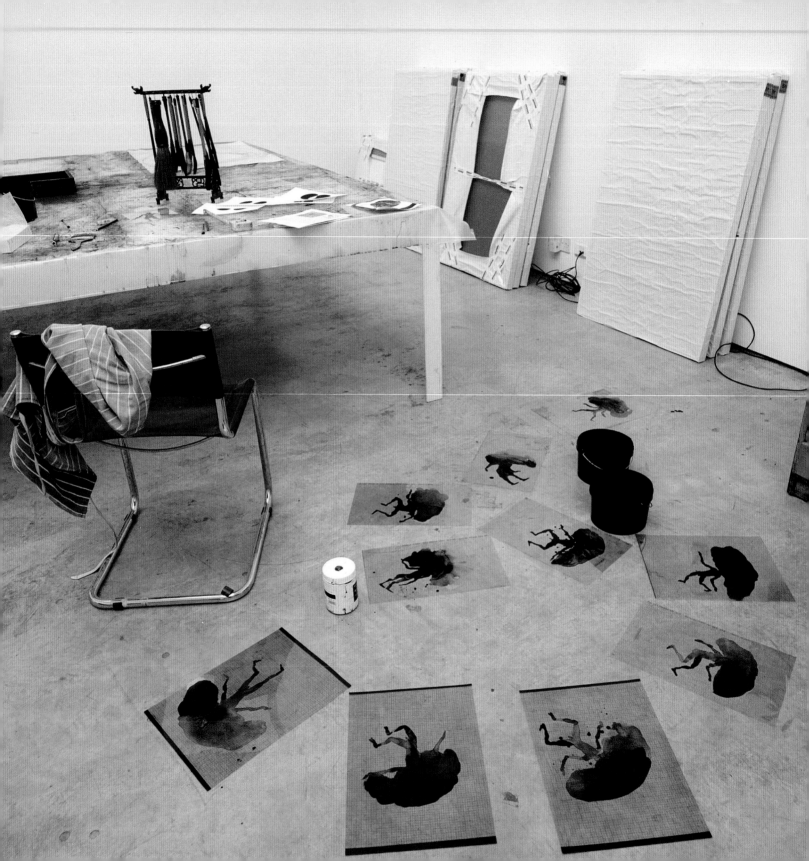

CONTENTS

Eamonn McCabe's images of we artists are not those images we have of ourselves. Consequently this visual commentary connects us with our work in a new way.

INTRODUCTION

In 2001 *The Guardian* first commissioned Eamonn to photograph me. According to him, my greeting was: "You're late," followed by: "No, you're not photographing me in the studio – all that arty stuff's so boring. We're going out." I stood by the Thames at Battersea, which most people mistook in his photograph for the Suffolk coast. A McCabe photograph has a life of its own and can foretell the future. I began to paint those North Sea waves at the end of the following year.

This series reveals artists and the mysterious hot-houses in which they work. Both are usually kept under wraps, but doors have been opened and the intruder trusted.

This is a fascinating collection of portraits of people and places, from Barry Flanagan's dining-room wall to Frank Auerbach's studio floor. The places are as diverse as their inhabitants and Eamonn's photographs portray visual facts, not trendy, glitzy effects. We are barraged today by superficial imagery achieved in a mechanistic way. Therefore the sheer straightforward honesty of Eamonn's work is rare and refreshing. No flattery, just a keen eyed and sensitive response to what is there, with no attempt at embellishment.

These images are therefore far from 'arty' and certainly not 'boring'. Eamonn is coming-don't move anything, rearrange anything or try to pose. Just be.

Maggi Hambling
February 2008

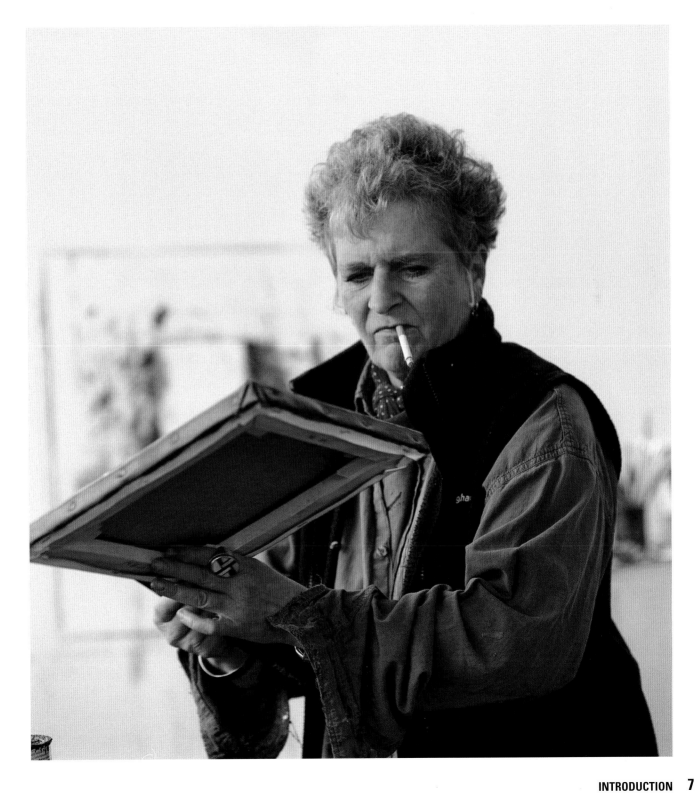

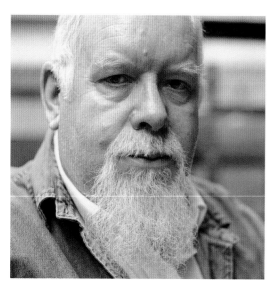

When the musician Ian Dury was an art student in Walthamstow in 1961, Peter Blake, who was teaching there part time, asked him what sort of things he liked. Dury listed rock and roll, boxing, wrestling, tits and bums, gangsters, teddy boys, Jayne Mansfield and Marlon Brando. "Then why don't you paint pictures of what you like?" Blake asked. Blake himself, of course, already was. That same year he won the junior prize at the John Moores biennial in Liverpool with the full length portrait of himself looking straight out at camera, so to say, wearing denims and basketball boots, the jacket liberally pinned with enamelled tin badges. It was an emblematic painting in every sense.

The following year the *Sunday Times* started Britain's first newspaper colour magazine and one of the earliest issues carried a piece by John Russell about Blake as a pop icon; the magazine's editor, Mark Boxer, wasn't likely to miss the next trick, and sure enough he began commissioning covers from Blake. From being a "fine artist" in the classical sense Blake rolled up his sleeves and got in to the muck where the brass is. Why not? There was no difference at all in his approach. His cover of Jean Harlow might as easily have hung in

PETER **BLAKE**

In his converted Hammersmith creamery the grand old man of pop keeps on working and building up his collection of bizarre and colourful memorabilia.

the Robert Fraser Gallery as his wrestling paintings of Baron Adolf Kaiser or Little Lady Luck could have illustrated a magazine. He had already painted Bo Diddley, the Beach Boys, and the Beatles (oddly, not the Rolling Stones, though he grew up along the road from Mick Jagger), so the commission to create a sleeve cover for *Sergeant Pepper* was a natural step, though Blake never got over having received a paltry £250 for the job.

But for all the talk about a coke culture, the American allusions and street cred subjects, there was constant awareness of history. His wonderful homage, *Have a Nice Day Mr. Hockney*, is the Courbet painting, *Bonjour Monsieur Courbet*, translated from rural France to metropolitan Los Angeles. One of his most cherishable works, produced in an edition of 10,000, was a wrestling painting called *Babe Rainbow*, which was silkscreen stencilled on to tin. But even if his work was acrylic on canvas it could look as though it was enamel on tin, though the hyper gloss might be softened by a landscape background atmospherically rendered with softly modulated freely brushwork like a English Impressionist.

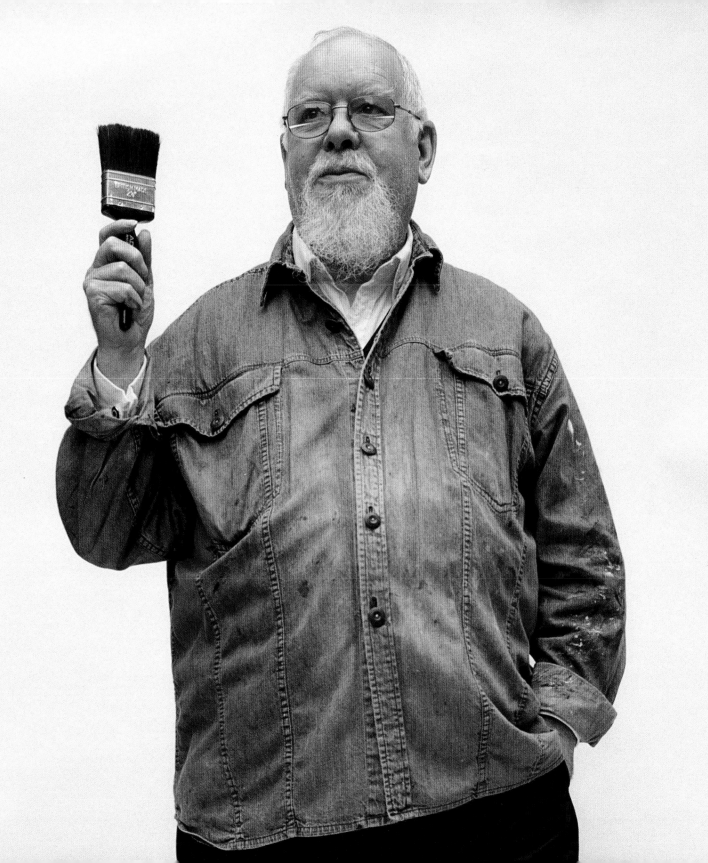

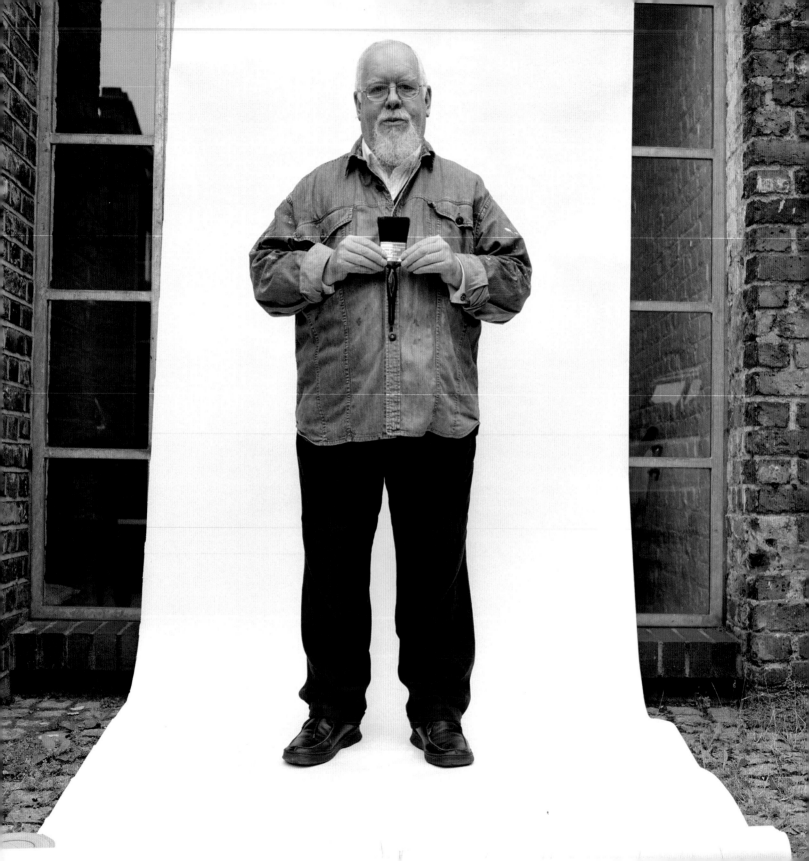

He lost his audience a bit when he became a ruralist, living in a country community, worshipping at the shrine of Samuel Palmer. And yet without breaking pace, here he is painting Titania from *A Midsummer Night's Dream* as wide eyed and innocent as his *Alice in Wonderland* illustrations, but head-on starkers and draped in charm bracelets and neck-laces with a chain of little medallions woven into her pubes. Meanwhile, he's accepted a knighthood and been elected a full Royal Academician but he carries on collecting potty memorabilia and exorcising the demons of dullness.

I took him [Lennon] and Ringo to the Pink Elephant. They were still pretty unknown, and when they got there they wouldn't let us in, even though they were playing 'Please, Please Me'.

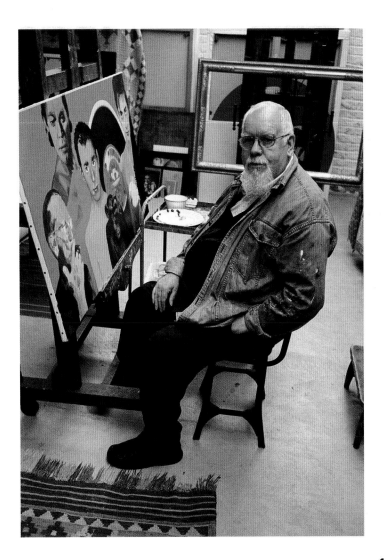

Every time Maggi Hambling takes up her brush she courts disaster, and often she achieves it. She won't mind that being said because she does not much care what critics say; anyway, the sales are critic proof. Eamonn McCabe and I once went to a private view at Snape Maltings of, I think, one hundred seascapes each priced at £999, the proceeds to be devoted to completing her huge seashell sculpture on Aldeburgh beach in tribute to Benjamin Britten; when we arrived all but a handful had already been sold.

MAGGI **HAMBLING**

One sock red, one green, a live cigarette between her fingers, stubs littering the Suffolk studio. The full bohemian kit. Don't be fooled, she talks about her muse but knows it only visits through daily slog.

She works all the hours she can, waiting, working, until the muse arrives, as she puts it. If the muse doesn't show up, Hambling destroys the canvas she's working on. It's tempting to feel that her best work is what she produces when the muse isn't on a high. Wakefield Art Gallery has a portrait of the former pugilist Charlie Abrew. He sits, alert and dignified in an electric blue suit with matching tie and pocket handkerchief picking up the purple and blue of his brown hands and his face as knobbly as a fist. His eyes stare out sightlessly because he was blinded exercising his profession. Hands are important in her portraits, like the arthritic hands below the brave face of Frances Rose, Hambling's Battersea neighbour in the 1970s. But there is no telling about her muse: for all the miscues, many of her later skyscapes adapt the colours of Charlie Abrew for liquid sunsets of the mind.

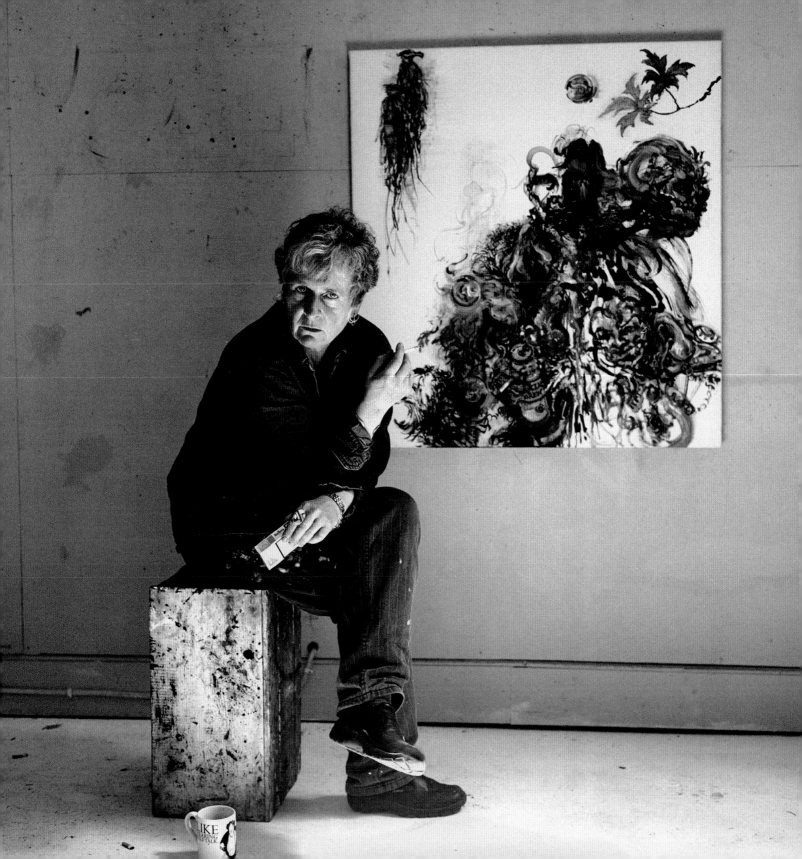

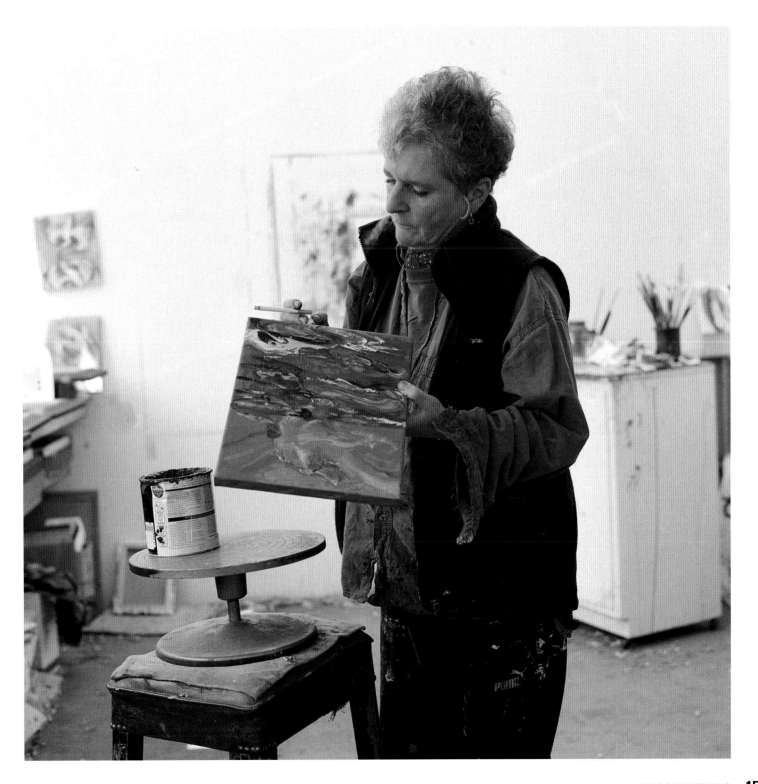

In the last years of her life (she died in 2006) Sandra Blow moved from London to St. Ives, where she had spent a couple of years as a young painter in the 1950s. Why did you move back? I once asked her, expecting her to tell me about the wonderful light and the freedom from the precious London art scene and the fine new Tate St. Ives; but no, she said, she came to Cornwall because she couldn't afford her London studio any more.

SANDRA BLOW

Even when she returned to London she drove regularly to the west country moorlands and painted in the open, not recording the scene but getting the elemental feel of the place.

That seemed, and still seems, extraordinary. She had been, as the painter John McLean wrote after her death, "the most amazing colourist and the most original composer of a painting we have had in recent years". But she was born at the wrong time, so while other artists revered her the market place moved on; she was a woman when women weren't especially appreciated in art schools except for their decorative qualities. But from the 1950s, when she found her feet, until her death, she never deviated from her commitment to abstraction and composed a body of paintings and prints that put her in front of British art.

She was a wartime student at St. Martin's School of Art and then briefly at the Royal Academy Schools. In 1947 she went to study in Rome. There she became the lover of the Italian painter Alberto Burri who was close to the Art Informel movement if only because as a prisoner of the Germans towards the end of the war he was obliged to use any materials he could get hold of, from sacking as a support to tar as a pigment. After the RA teaching Blow said she found the experience of Italy like being in paradise; but although it was a huge liberation, she also felt suffocated by Burri's strengths; she understood that he had made an abstract language that could not be expressed in any other form; but also that it was rooted in the classical rhythms of Italian art and the sunbleached landscape, an experience this daughter of a Spitalfields fruit wholesaler couldn't hope to share. In 1949 she came back to England and during her year in Cornwall found what she was seeking: Burri's language of rough "inartistic" materials translated into English, an abstraction that looked vigorously gestural but whose instinctiveness was unerringly composed, a sweet balance of colour and form. She attached hessian, that popular interior design hanging in postwar arty circles, to her canvases or boards instead of the wall, she scrubbed pigment on, scythed on charcoal, pasted on paper for its brilliant hard colour against the textures and atmospheric subtleties of her brushwork. The paintings were airy and improvisational,

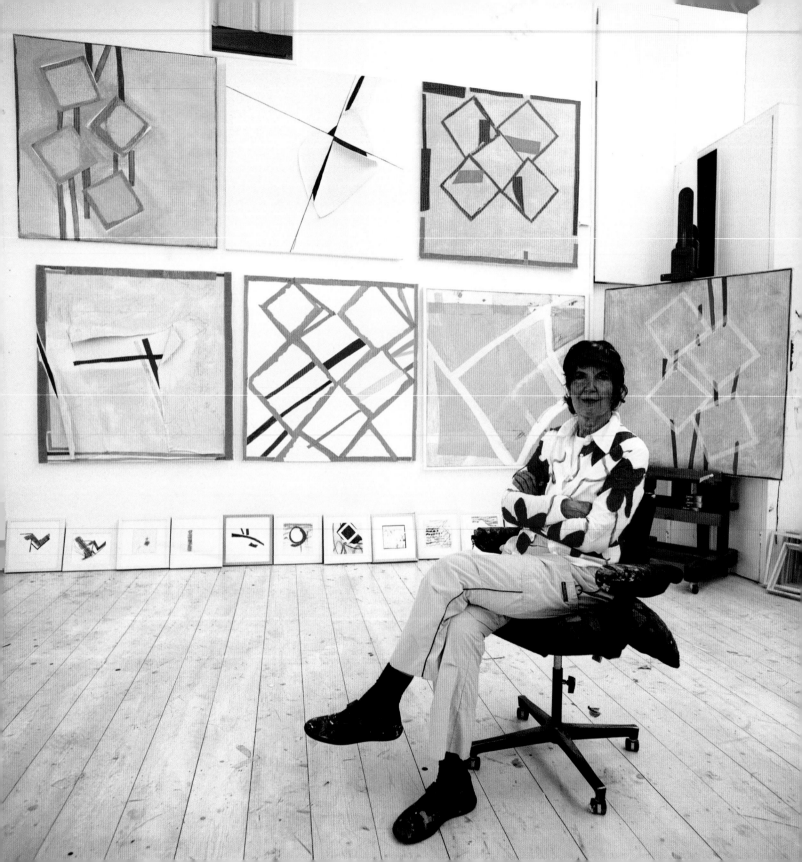

with a sense of the wind and sea spume, based on the tough landscapes of the Penwith peninsula but not landscape painting. Even when she returned to London she drove regularly to the west country moorlands and painted in the open, not recording the scene but getting the elemental feel of the place.

When she left her Chelsea studio (below) and returned to St. Ives in the 1990s she called her first big painting following the move Porthmeor, possibly after the scene outside her studio, but more likely it was less a case of naming it for the landscape than noting that her new studio was one of that terrace of basements above Porthmeor beach where fishermen had once stored their nets; later Ben Nicholson had worked there, and Patrick Heron, even briefly Francis Bacon. It might even have been construed as a homage, except that Blow was too much her own woman to do homage. Curiously for such a broad brush expert, her work was anchored in drawing. In the 1970s she collaborated with a young poet, Alaric Sumner, on a book called *Waves on Porthmeor Beach*; her silvery, atmospheric drawings stand as a reminder of her finely honed creative sensibility, something that translated into the late canvases and prints, as brilliant but controlled explosions of colour.

ANTHONY EYTON

"I like having a problem to solve, pitting my wits against the evidence of the senses. I want to be accurate in resolving the problem, to meet the challenge of light and colour and sense of place"

The Chantrey bequest has been a poisoned chalice for the Tate ever since it began in 1897. The nineteenth-century sculptor Francis Chantrey had intended the fund to enhance national collections with new purchases, but the cash was administered by the Royal Academy, and the RA's idea of enhancement was to use the funds to buy works from its own members for the national collection; this was not what the Tate regarded as cutting edge art. There was a short period of serene relations in the 1980s when Alan Bowness ran the Tate and Hugh Casson the RA, and they agreed on the purchase of Anthony Eyton's *Open Window, Spitalfields* (Eyton taught at the Royal Academy Schools for 35 years and became an RA in 1986); in any case, the Tate hasn't held it against Eyton, and when Bankside Power Station was being converted into Tate Modern it included him in a small group of artists invited to come and record the rebuilding work.

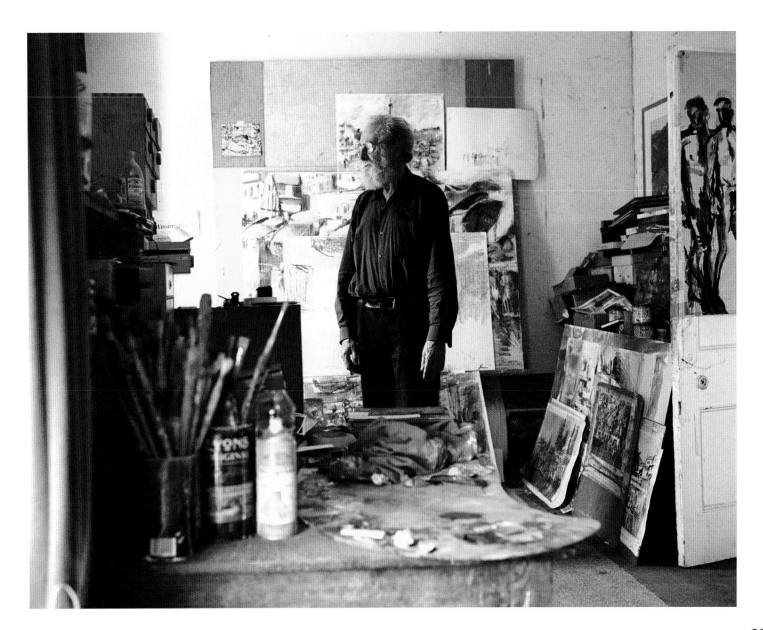

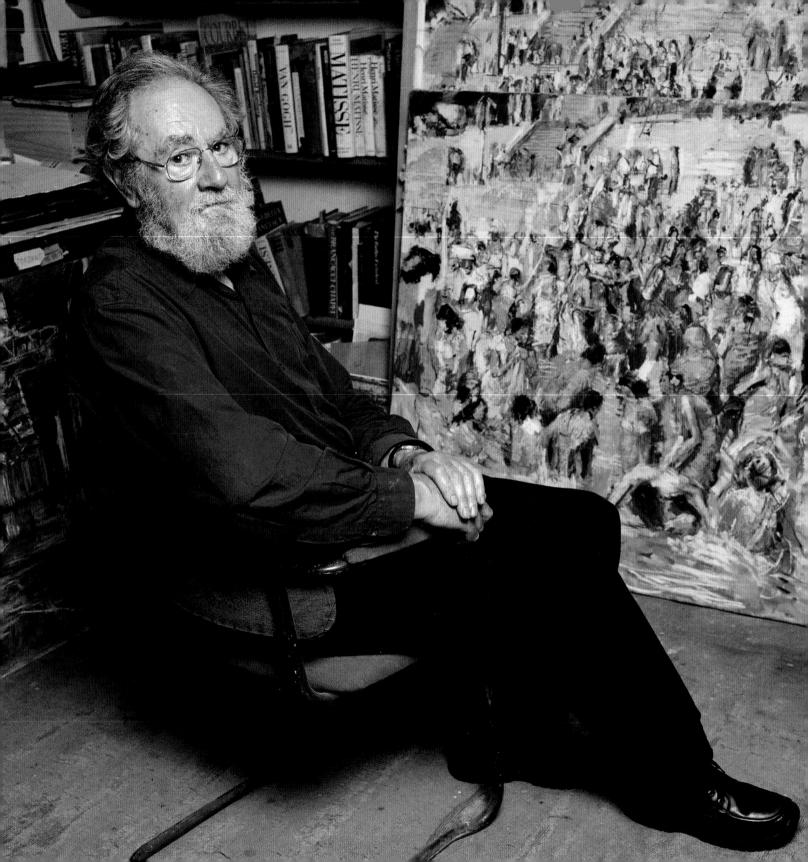

Now in his eighties, Eyton is an old pro and a survivor of the famous post-war art course at Camberwell School of Art, made in the image of William Coldstream, a painter who taught a measured almost dessicated approach to the subject. Students either loved it or rebelled. Eyton stuck with it but with an eye on the Sickert way from which Coldstream had developed of a meat, gravy and two veg school of English realism. Eyton's eye, educated in Impressionism and Post-Impressionism catches the sparkle of light in the dimmest interiors, light gleaming off the brass boiler at Bankside, or filtering through the glass roof on to the striped awnings of Brixton Market. The Impressionist influence is unhappiest in the holy city of death and prayer, Varanasi (Benares), where he makes the bathing ghats look like the Isle de la Grande Jatte in Seurat's great painting in the National Gallery; the brown Ganges has never before looked so sparkling nor the bathers so frolicsome.

Eyton is widely travelled but most of this has been for commissions like recording the Gurkha Regiment in its last days in Hong Kong and scenes at the Addis Ababa embassy in its centenary year, and in the nature of it these are simply very good illustration; there are too some beach scenes from Brazil which make the heat of the day almost tangible, but he is better in an English climate. He is most at home, well, at home: either in his studio, in his back garden on the Kennington Road or in the most popular garden in England, the Eden Project, where he became resident artist in 1999 and made highly imaginative compositional use there of the structure of the geodesic domes.

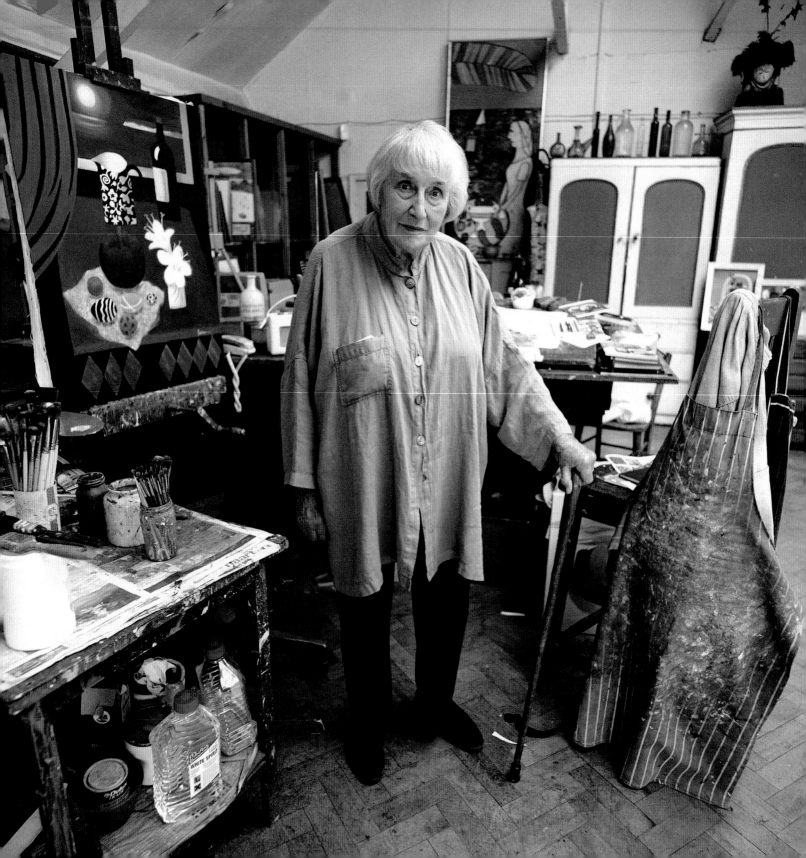

There were a few female toughies around in the 1930s art world, like Winifred Nicholson and Barbara Hepworth (first and second wives of Ben Nicholson, as it happens), but women and needlework remained a more natural conjunction. Mary Fedden left school in 1932 when she was 16; her first stroke of good fortune was to be taken on by the Slade, the first British art school to give girls equal opportunities; her second was to study theatre design under a Russian who had worked for Ballet Russes, so when she left the Slade and opted to be a painter she had horizons that were wider than usual.

MARY FEDDEN

Home and studio by the Thames in Chiswick were built as industrial sheds, but for sixty years Fedden has lived there with her stock of visual memories and collection of bottles and pots to make work that juggles with reality and invention.

True, Fedden works in the English tradition, but that is not to say that she's a traditionalist; her painting and print making mark a lineal descent from Nicholas Hilliard to the English modernism pioneered by Ben Nicholson and William Scott. She fell for her husband Julian Trevelyan, already a successful printmaker, when she was still a student, and was there in 1949 to pick up the pieces when his first wife left him. He taught her his craft, and the almost enforced abstraction of the medium, in which mark becomes as important as subject, released her singularity. A typical (but exceptional) Fedden lithograph called *Straw Plate*, has a still life of fruit lithely outlined in the foreground and behind a church on a hilltop composed of marks that look like God's thumb prints.

The Tate has another one showing an etching table and an oil of the same subject which are effectively a commentary on her approach. Each has a similar collection of objects on the table, a bottle, a container with brushes, a rag; but in the painting quite naturalistic dribbles of ink run off the table surface, knowingly like the dribbles on an Abstract Expressionist work; but whereas the painting is set in an interior the etching is in a landscape, and here, in a medium in which dribbles can't dribble, they become a graphic motif rhyming with the texture of the table top and the furrows of a distant field.

All her life Fedden has stuck with the same elements, a bottle, a plate, a flower, an occasional human figure, an ideogram for the sun or the moon, shapes a textile designer might make, but subtly varied, endlessly evocative, poetically satisfying, apparently effortless but founded on a lifetime of looking.

"I fill notebooks with sketches, just using black Pentel, but I paint nowhere except here in the studio"

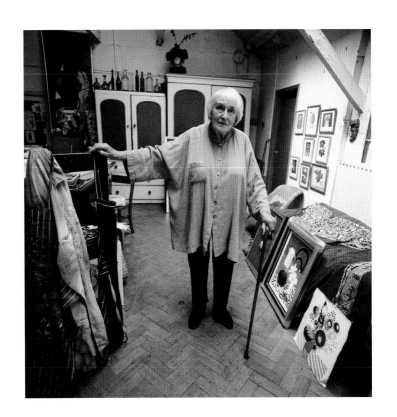

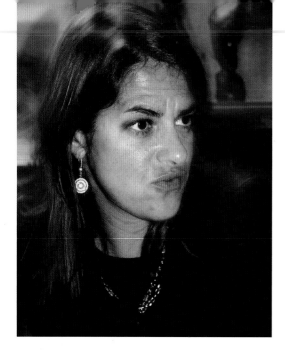

TRACEY EMIN

She gets off on sluttishness, but her architect designed studio is impeccably organised and today she can afford to live in one of the old silk weavers houses in Spitalfields.

Emin's *My Bed* is the flip side of François Boucher's erotic *Miss O'Murphy*, in which the naked post-coital woman lies belly down on tumbled sheets. Emin says she is not much up on art history so the comparison may never have occurred to her, but it's indicative: Boucher's work is frankly erotic, Emin's frankly sordid; it is 'my' bed, so it is 'my' contraceptives, 'my' fag ends, 'my' pantyhose discarded casually over the end of the bed. She has transformed her abused past and proletarian sluttishness into art. Maybe it's too narcissistic to be tragic art, but it constitutes a powerful social document.

She is, *The Guardian* wrote, a 'media tart and headline junkie' and it isn't just the red tops that take an interest. Some day, if she can keep her anger intact, all of us may wake up to acknowledge her work too.

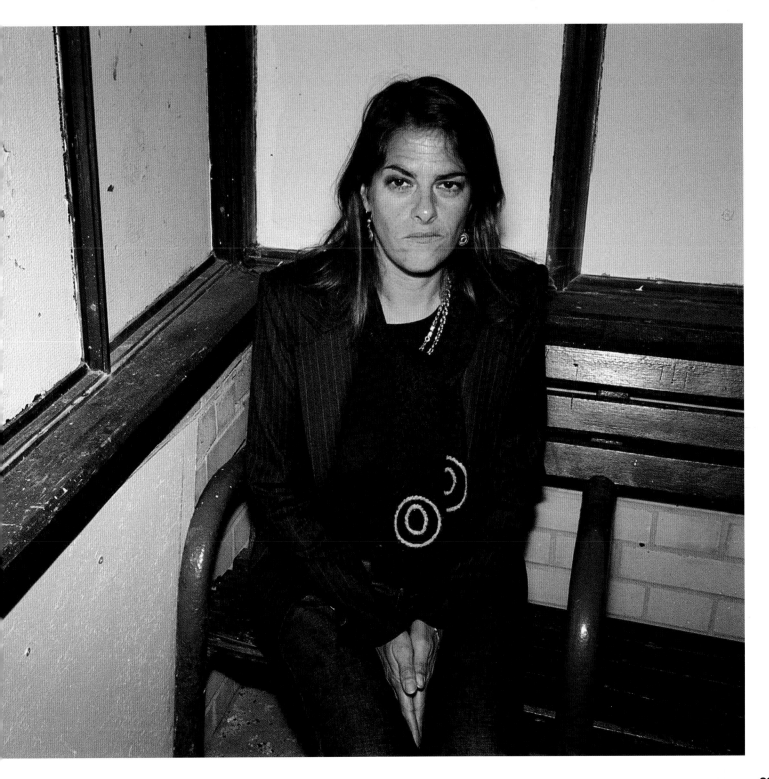

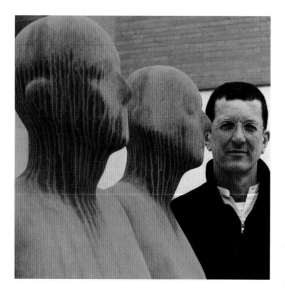

First of all there is the Angel of the North, because it's the best known, seen by more people on earth, maybe, than any work of art apart from the Statue of Liberty; and maybe it's the most successful, a threnody in riveted steel for the Geordie heavy industries of coal and iron, and the steel for the angel's massive wingspan and soaring height, riveted together like one of the vessels built in the Wearside shipyards and raised on a hillock above Gateshead. Next there are the silent watchers of the Mersey estuary, a handful of them constituting a work called *Another Place*, on Crosby beach and in the sea, watching with blind eyes.

ANTONY **GORMLEY**

He works in a hi-tech space, more machine workshop than art studio, with enough assistants to pick a football team from, but the sculpture goes back to first principles, and there's much more to it than lonely, featureless humanoids.

Gormley's work has seemed to many people to say enough about the much touted human condition to make it worth erecting his sculptures in great city centres and remote, but not too remote, places where they stand as a reminder of our inner being. For stand they mostly do, though there are those other sculptures in the negative, as it were, the impress of human forms in a bed of bread and wax, like the deep impression of Anthony Perkins's mother's corpse in a mattress in Hitchcock's *Psycho*, but magisterial rather than terrifying. If there is a danger of this run of work being dulled by acquaintance, Gormley is a great inventor of the simple, powerful statement, visualisations charged with the weight of their own material: *Re-arranged Tree* made of a long row of discs of sliced elm; *Breadline*, which is a line of bread fragments a thousand inches long by an inch and a bit wide; simple stones, basalt, bluestone, Devon stone, engraved with marks like giant fingerprints or with the incised outline of a head and a hand, rudimentary sculpture that stops you in your tracks.

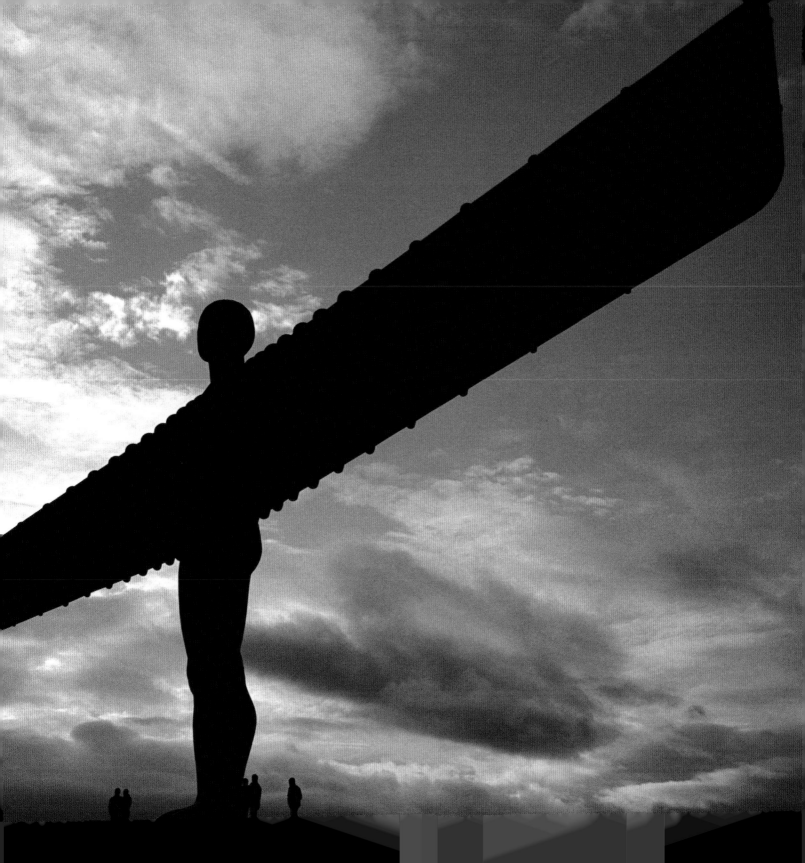

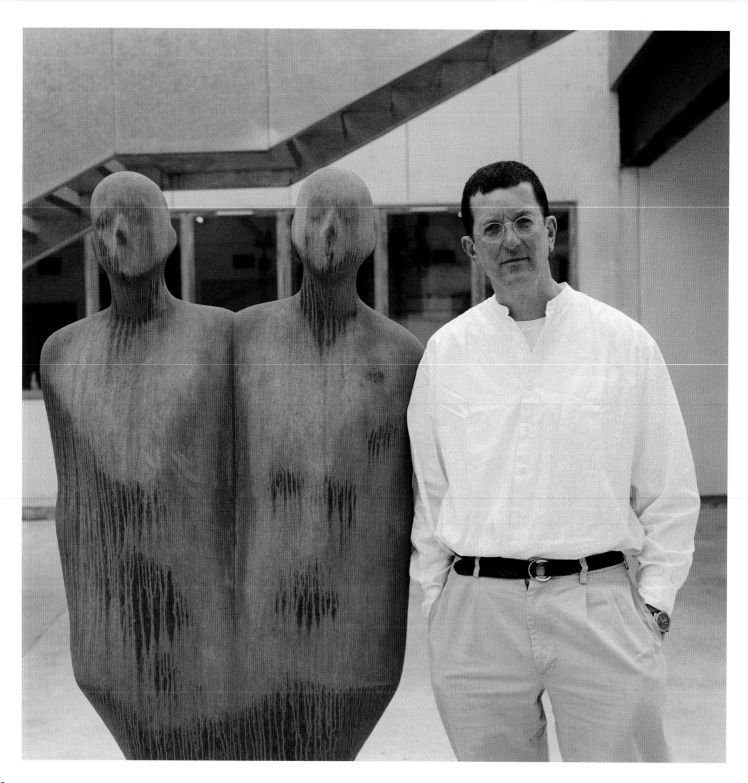

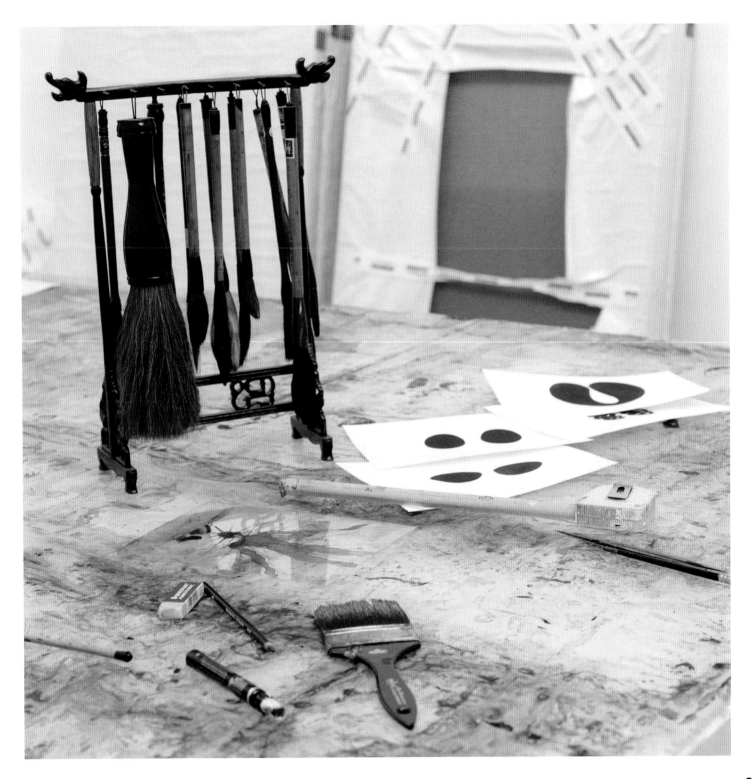

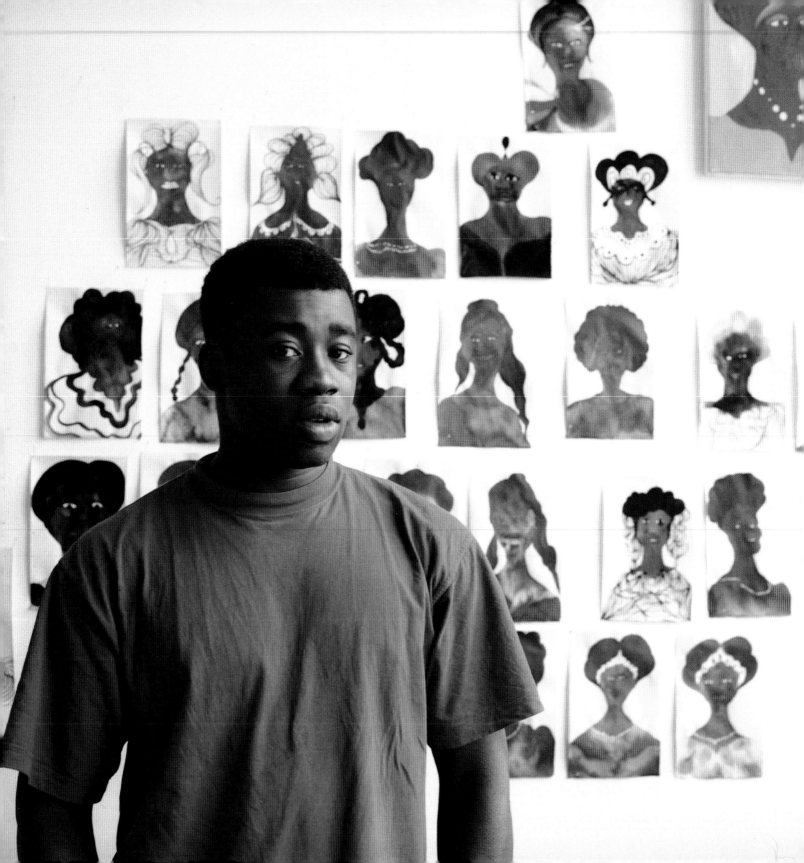

The Tate was outside the law when it bought work by Chris Ofili while he was a trustee. Lots of sound and fury, but when the smoke had drifted off the battlefield and the Tate had promised to behave itself, it remained intact with the finest ensemble of contemporary paintings since Rothko gave it his Seagram murals. Ofili's *The Upper Room* is thirteen paintings in a room specially devised by his remarkable contemporary at the Royal College of Art, the architect David Adjaye. The paintings and room are a unit, which can be disassembled and reassembled (shame, because it means it's not, like Rothko, on show constantly). It is lit like a chapel and with

CHRIS OFILI

He doesn't exhibit often but the power of his ideas has converted the public. In The Upper Room Christ's golden nimbus is painted dung and this time no one threw a tantrum.

Ofili's familiar mixture of sacred and profane, drawn from Africa, the Caribbean, the folk culture of Spain; a familiar mix, but constantly renewable, the subjects now less shockable than in 2000 when Mayor Giuliani of New York threatened to withdraw the city's grant from the Brooklyn Museum of Art because it showed Ofili's *Holy Virgin Mary*, a black virgin with moulded elephant dung for her right breast; and in Canberra the National Gallery of Australia backed off showing it at all.

What is familiar now is Ofili's yoking of black culture and history to the facts of black life in the modern world. He first brought elephant dung back from a visit to Zimbabwe (no, not in a trunk) and now has the stuff delivered from London Zoo. Ofili doesn't exhibit often but the power of his ideas has converted a public which recognises the connotations of dung as a symbol of a non consumerist way of life (in *The Upper Room* Christ's golden nimbus is painted dung and this time no one threw a tantrum). The critic Adrian Searle aligned Ofili with Henri le Douanier Rousseau when he pointed out that Rousseau's paintings too would be silly "if the world he imagined hadn't been so heartfelt". Ofili's exotic pattern making, like Art Nouveau tendrils gone back to wild nature, and his lustrous greens, pinks, yellows, blues, and glowing whites like stained glass are hypnotically beautiful.

In the potted biographies that publications run to enlighten readers about the contributors, Chris Ofili's invariably appears as: "Chris Ofili lives and works." It's a joke and a truth that, like the art, bears repetition.

"Chris Ofili lives and works."
It's a joke and a truth that, like the art,
bears repetition.

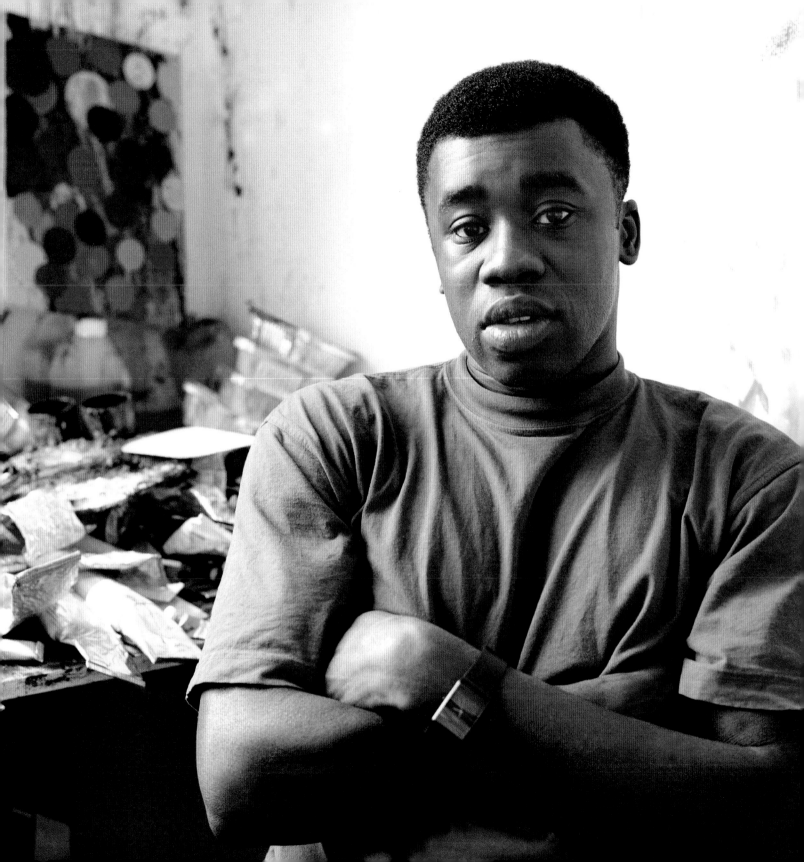

After Osama bin Laden's destruction of the twin towers Art Spiegelman could think of no better way into his book about the outrage than to pillage the work of New York's finest comic strip artists of the twentieth century, collage new words into the speech balloons and introduce himself as a character in the fateful events. He produced the book, *In the Shadow of No Towers*, as pages on board which opened out into broadsheet newspaper size like the original newspaper comics. It might have seemed a shockingly trivial response except that he had already explored the Holocaust in two volumes of comic strip narrative, *Maus I* and *Maus II*, which swiftly became accepted as powerful testimony and a brilliantly told tale.

ART SPIEGELMAN

He has taken the two streams of underground and mass readership comic strips and channelled them into a political and social commentary of power and flexibility capturing universal tragedy in personal trauma.

For Spiegelman comic book artists are, to borrow from Shelley, the unacknowledged legislators of the world. Like Robert Crumb, he has made an underground art into a mainstream political commentary. More than that, the *Maus* books take the narrative of Spiegelman himself becoming involved in the current unsatisfactory home life of his old father, Vladek, as he interviews him about the Nazi years in Poland. In the narrative, the Jews become mice and the Poles pigs — vermin and swine is what the Nazis called them, but on the pages the device acts like masks in a Greek drama, concentrating the reader on the molten core of the tragedy. As often as not Vladek is on an exercise bike as he reminisces and an early frame quite casually shows the camp number tattooed on his wrist; later, when Anya has been repatriated and is waiting for the return of Vladek, she looks at a photo of him, and Spiegelman incorporates the actual snapshot of the non-mouse Vladek into the running story. It's a style of great flexibility, fluently able to suggest personal trauma, luxurious interiors like the prewar home of Anya's parents, and the bustle of a great city square.

He needed twenty years or more to put *Maus I* and *II* together; the two towers book seems more provisional. Spiegelman's first response, for a *New Yorker* cover, was to borrow from Ad Reinhardt's black on black canvases to show two ghostly black skyscrapers against a modified black ground, a metaphorical ground zero. He re-uses it as the cover for *In the Shadow of No Towers*. It's a neat graphic, and between the covers are some inspired ideas; but *Maus* is inspired full stop.

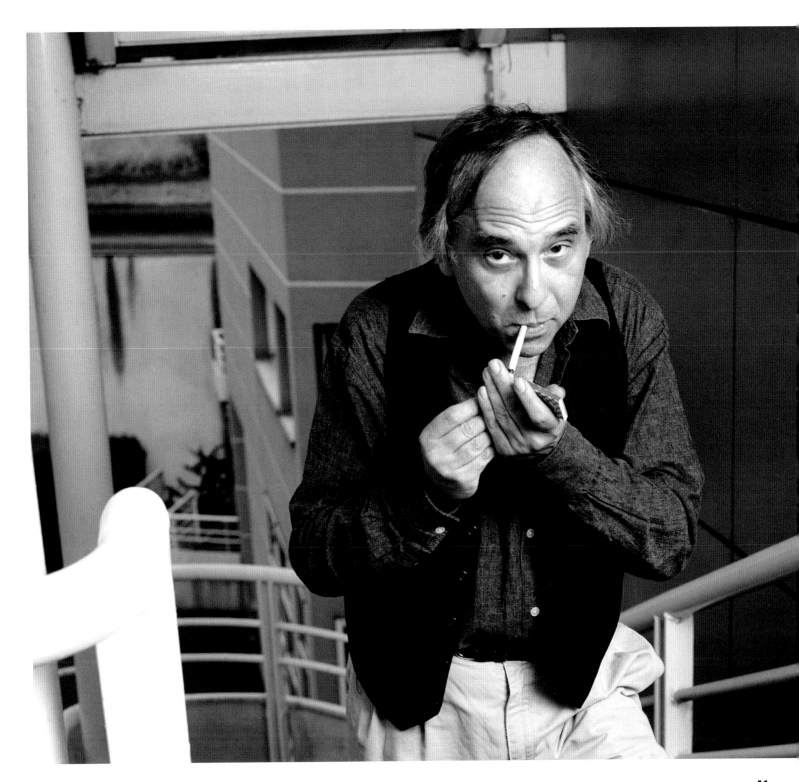

Enough pigment has been brushed on to canvas since her first New York show for Bridget Riley to be comfortable with her studio being called a production line. It is a house in Holland Park with a staff of ten assistants, more or less, in a working area over four floors. In 1965 it was all so different. Then she had a brilliant success with a sell-out first New York show, but found her paintings being ripped off for fashion and soft furnishing designs. There was, she discovered to her chagrin, no legal remedy, and though she fought successfully for intellectual property rights in painting to be adopted in American law, willy nilly she became

BRIDGET RILEY

She co-ordinates a team of assistants in a well-ordered London house like a renaissance master in a botega. Not surprisingly, her Op Art sources stretch into the fifteenth century studios of Masaccio and Piero della Francesca.

part of the swinging sixties, the fashion period of Mary Quant and Biba, somewhere she had no desire to be. But her belief in herself held and in 1968 she and Philip King shared the British pavilion at the Venice Biennale where she won an international painting prize.

She started as a painter of nature and in once sense never stopped: the brilliantly articulated surfaces, the undulating stripes, colour or hard edged black and white, the interaction of tone and form have their genesis in natural effects like the glitter of sunlight on water. These are classic abstractions with an intellectual source as well reaching back to Masaccio and Piero della Francesca. They are an equivalent to the experience of nature which, in Riley's own words, disclose "some intimations of the splendours to which pure sight has the key".

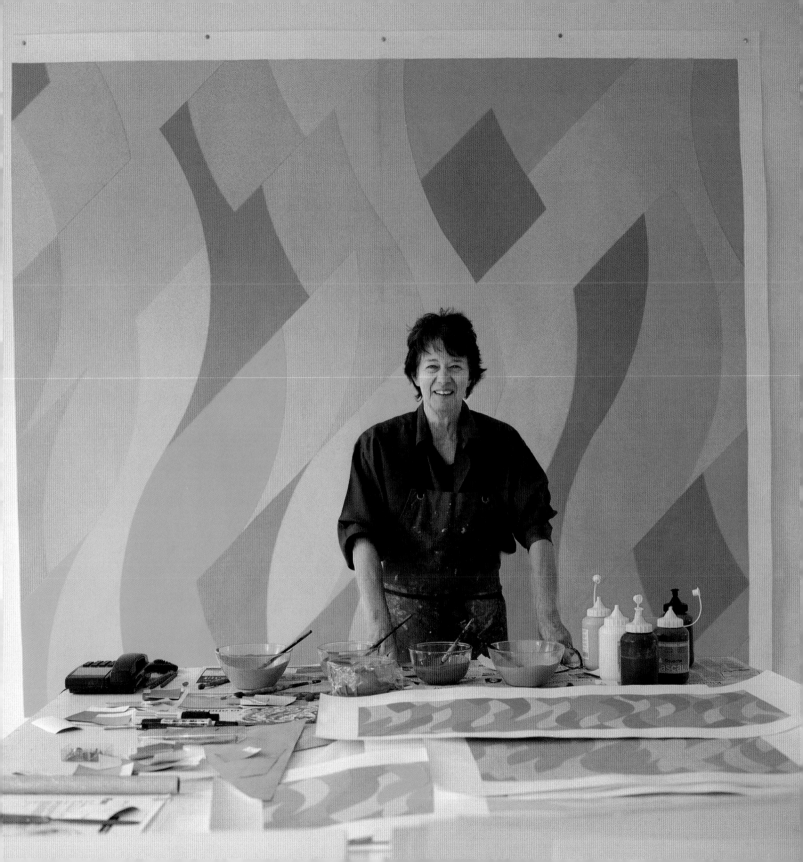

"The artist today is still, essentially, a very isolated person, he must transform it into his own definition of freedom"

Among his many takes on Picasso there's even a self portrait similar in feeling to the old man's shocking death's head autoportrait. Only with Hockney we don't quite believe it. We know the fate in store for golden lads and lasses, but this particular golden lad seems forever youthful. His directness of response, his happy acknowledgment of his homosexuality, his self knowledge and Yorkshire grit, his sheer charm (not necessarily a Yorkshire attribute) has carried him through his career, a series of brilliant successes which have influenced him no more than imminent failure, a tall poppy who has refused to be cut down.

DAVID HOCKNEY

The huge studio in Los Angeles is both workplace and, without the intention, a Hockney art gallery. Powis Terrace in Kensington has been his London home and studio for decades. Recently, he has added the Yorkshire coastal town where his sister Margaret lives.

Imminent failure, of course, lasted only until he came into the straight at the Royal College of Art. The teaching staff wrote off Hockney and the best of his year as beyond redemption, talents like Peter Phillips, Derek Boshier, Allen Jones, Patrick Caulfield; but one day Richard Hamilton, who was teaching part time in the interior design department and already famous as the painter of the seminal *Just What is it that Makes Today's Homes so Different, so Appealing?*, was invited across to the fine art department to do a critique and award a £5 prize. Hamilton chose Hockney and staff animosity vanished like snow on the equator. But Hockney hardly noticed staff attitudes; he had already picked out an older student, the figurative painter R.B.Kitaj, as his mentor.

Leaving college with a rarely awarded gold medal, he sold his *Rake's Progress* series of etchings to Editions Alecto for £5,000 and used that to launch his career with his first year living in Los Angeles. Nobody paints the west coast like Hockney, sunlit, squeaky clean, fat and sleek as a Chevrolet. When Hockney accepts portrait commissions in California he does it on his own terms; he may ask the sitter to come to his factory sized studio or if the fancy takes him he will paint the sitters at their home, standing before a sliding glass wall in a concrete garden with a concrete barrel holding a single exotic plant trained into submission; people awkward in their wealth and finest clothes and no more important to the painting of their wealth than the portrait of the house and pool. *Mr. Andrews Jnr and Mrs. Andrews.*

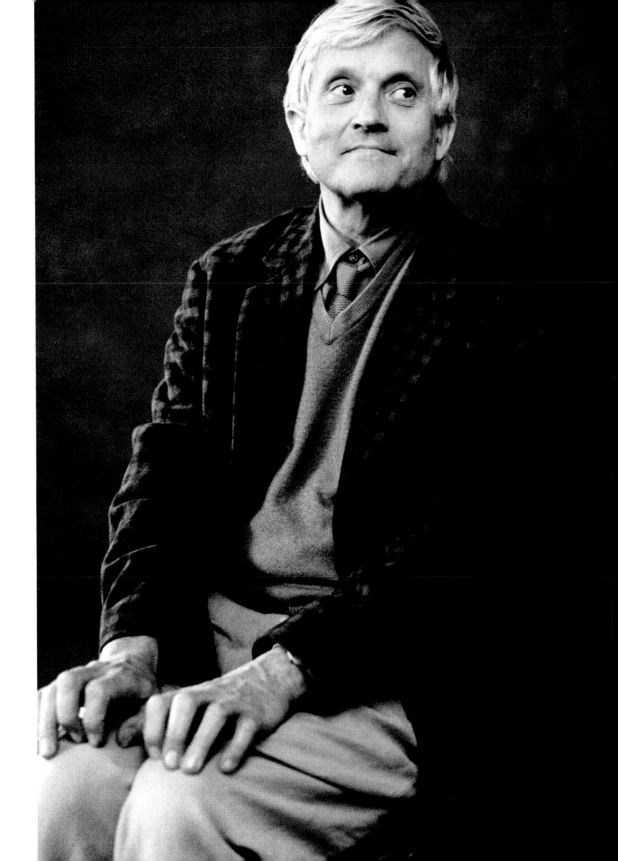

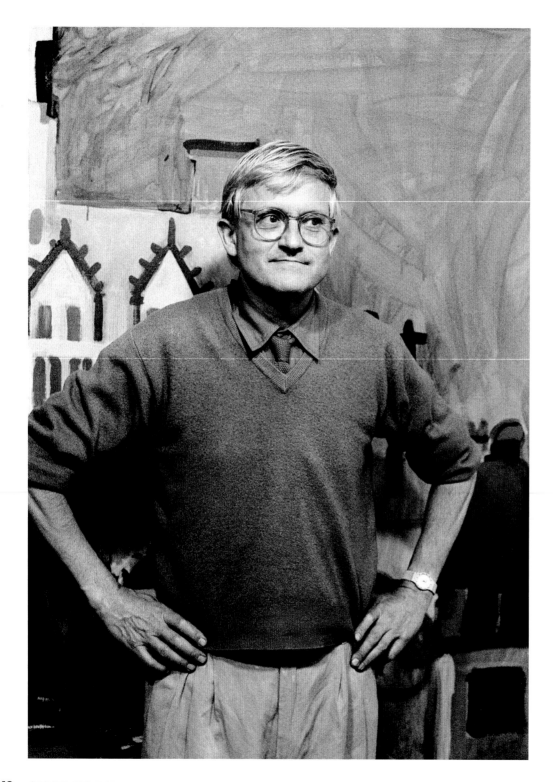

As the exhibition at the National Portrait Gallery in 2006-7 showed, portraits are the unfashionable core of his art made once again high fashion. They are both demotic and democratic: he paints the famous people he has met in Hollywood, but he painted his mum many times through her life, he paints his friends and, when the National Gallery invited him to paint something inspired by a master he admired, he made a lovely sequence of a dozen gallery attendants called *12 Portraits After Ingres in a Uniform Style* (1999-2000). His portraits showing his friend Celia Birtwistle growing older are some of the tenderest ever made: such as the famous crayon drawing in which her pale pink-tinged face echoes the colour of the pink tinged white tulips and her fingers are more slender and delicate than the petals: it's quite clear that the artist loves the model. He has made portraits in pencil, crayon, acrylic, oils, Polaroid assemblage and watercolour and ink. He is fascinated by process, and by the purely pictorial problems of illusionary space and style. He paints through the problems and he wrote a brilliant historical account of artists' use of optical instruments in his book (and TV series) *Secret Knowledge*. Possibly his first really accomplished portrait is of his father, done in 1955 when Hockney was 17 or 18 and very much a product of the kind of Euston Road impressionism that held sway at the time; but a year earlier he had made a self portrait lithograph that more clearly points the journey he would make into art as artifice. It shows the boy David against striped wallpaper in a striped tie and striped trousers: quite why he was togged up like that is anyone's guess, but pictorially it demonstrates an absorption in pattern and flat spatial planes that points to his future, to work such as his second shot at the *Rake's Progress*, the stage designs for the Glyndebourne production of the Stravinsky opera with their translation of the crosshatching of Hogarth's original etchings into the dominating structural element of the stage picture.

He has borrowed openly from Picasso and Matisse; openly and playfully, because everything remains Hockney, everything is smiling and looks effortless. This is the quality that prompted Robert Hughes to characterise Hockney as the Cole Porter of modern art. How that is read depends on how you see Cole Porter as an artist. The comparison might as easily have been with Stravinsky.

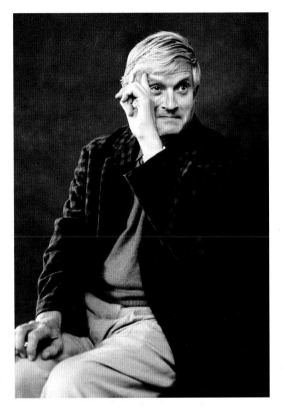

"People in the arts are not really looking at the past sufficiently hard"

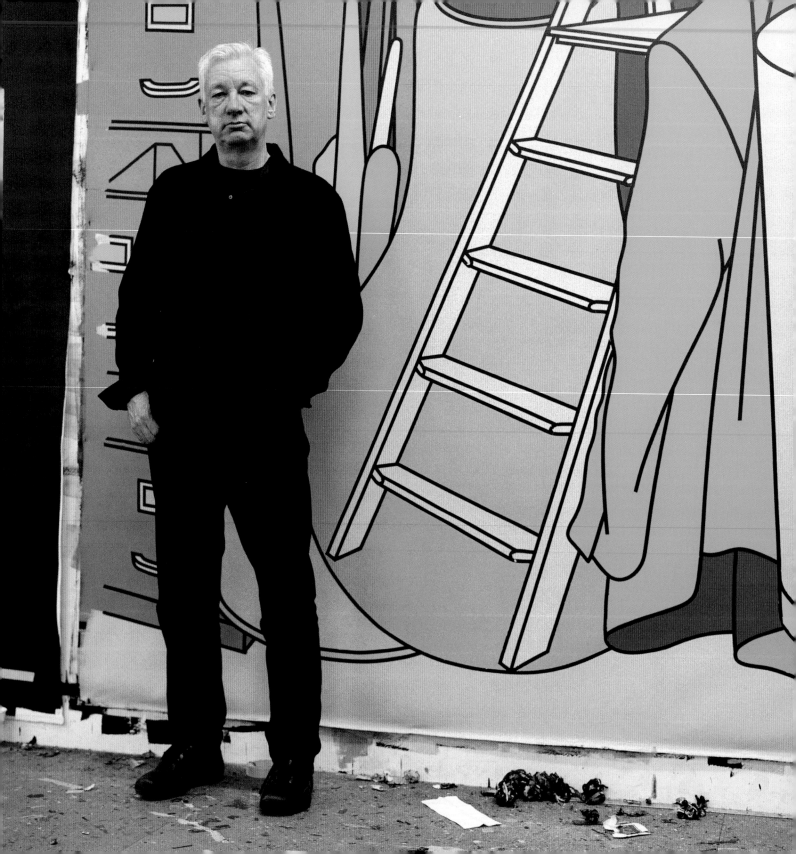

Oak Tree is Michael Craig-Martin's most celebrated work, not because it's his best but because it has provoked so much scepticism, not just from critics but also from many of his peers. *Oak Tree*, of course, is a glass of water standing on a glass bathroom shelf in, as it happens, Canberra at the National Gallery of Australia. Most of the criticism focuses on the improbability of a glass of water being an oak tree and neglects the text which accompanies the work. This takes the form of a Platonic dialogue (that is, Michael Craig-Martin interviewing Michael Craig-Martin). The interviewee maintains throughout that the glass off water is an oak tree because the artist has designated it an oak tree, — compare Marcel Duchamp's *Fountain*, which is actually a pissoir (or not, since galleries have taken Duchamp at his word and exhibited it as a work of art). At one point, with sleek legerdemain, the Craig-Martin text goes:

MICHAEL CRAIG-MARTIN

His kit of tools and templates are utterly simple and everyday, tables, ladders, filing cabinets, sunglasses, office chairs, all of them more or less anonymous industrially produced objects carrying no emotional overtones.

"Q. Isn't this just a case of the emperor's new clothes?

"A. No. With the emperor's new clothes people claimed to see something that wasn't there because they felt they should. I would be very surprised if anyone told me they saw an oak tree."

The main thing to remember about Craig-Martin is that when he came to Britain from the United States aged 25 in 1966 he made his reputation as a conceptual artist; in a sense, he remains one. His kit of tools and templates are utterly simple and everyday, chairs, tables, ladders, filing cabinets, buckets, sunglasses, trainers, mobile phones, coffee percolators, office chairs, glasses of water, all of them more or less anonymous industrially produced everyday objects carrying no emotional overtones but which he deploys in commercial-looking colours in vivid and beautiful combinations, exploring the flatness of the surface and the spatial illusions of perspective, the complexity of form, the interplay of realism and ideogram; all those things that art has always done.

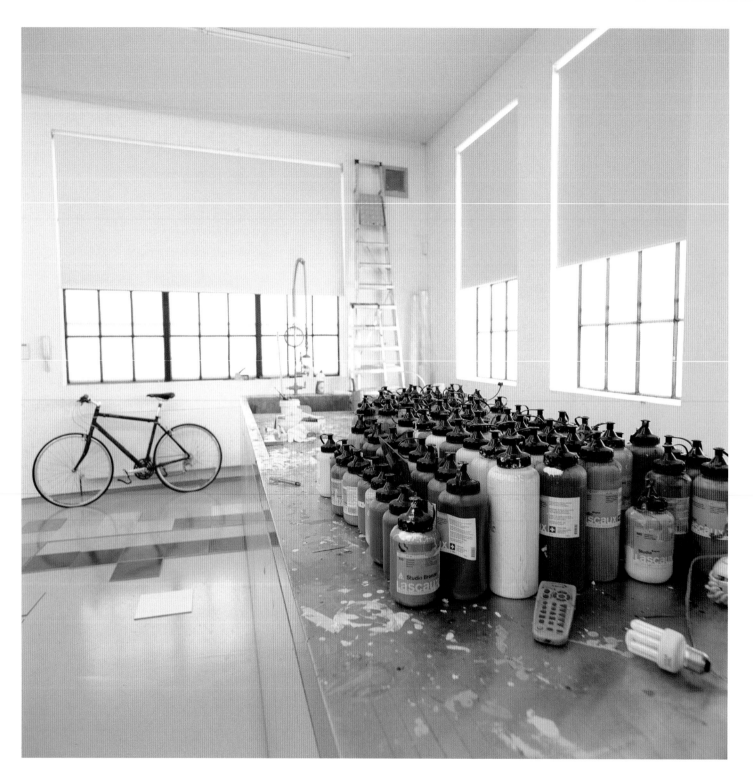

Coming fresh to this country just before the big social changes in the Thatcher years gave him an uncluttered view of what mattered to the up and coming generation of artists: he became a famous and formative teacher at Goldsmith's of a group including Julian Opie, Damien Hirst, Gary Hume, and Lisa Milroy; part of Cool Britannia, an evanescent concept which, in the hands of Craig-Martin and the younger Goldsmith's group, was made visible.

"You can't have the top heights of cultural achievement without a very big pyramid base. It's a pyramid and the bigger the base, the stronger the pyramid, the higher it can go"

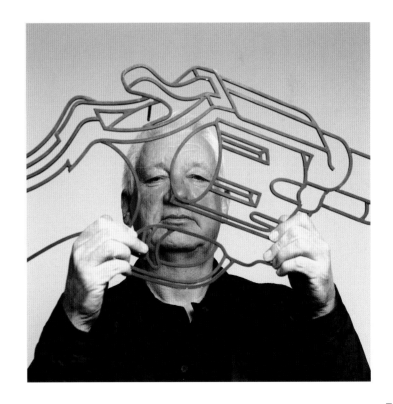

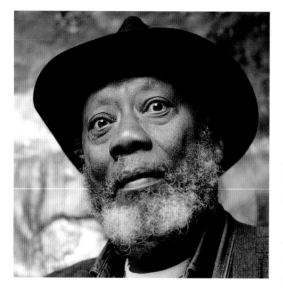

After Frank Bowling won a scholarship in 1959 to study at the Royal College of Art, Carel Weight, the professor of painting, warned him that if he showed any proclivities for abstract art it would not be good for his college career. So Bowling stuck to figurative art (though he continued with his thesis on Piet Mondrian). His choice was made easier for him because he was a college contemporary of figures like David Hockney, Ron Kitaj, and Derek Boshier (after graduation in 1962 Boshier and Bowling took different rooms in the Grabowski Gallery for their first solo shows). At the age of 30 Bowling paid his first extended visit to the United States where the critic Clement Greenberg, who frequently visited Bowling's studio, told him that on no account should he continue his career as a figurative painter. Greenberg was eloquent and persuasive to the point where he held New York and most of its artists in thrall for many years. Bowling was persuaded.

FRANK **BOWLING**

He was the Royal Academy's first black artist, and blackness has been a theme of his work from the tropical exoticism of his palette to the silky white on black of his website.

In fact he was already moving in that direction. His early work was a form of expressionism, self-portraits with oil paint knifed thickly on to the surface, a nightmarish, congested Four Horsemen of the Apocalypse, then a sequence of birds (dead?), black against a thickly laid in white surface, and a row of bottles, white on white. When the Royal Academy produced its big survey show called *British Painting 1952-1977*, it included a Bowling canvas called *Mirror*, painted in 1966 just before he went to New York: in the centre of a drum-shaped room with an Op Art pattern on the floor a spiral staircase climbs towards and then apparently into a ceiling mirror; the painting shows an exhilarating mastery of baroque complexity in form and space controlled by a lucid pictorial intelligence. After he had acquainted himself with the American colour field painters like Jules Olitski and Kenneth Noland he had shed the skin of figuration by the time he returned to Britain — ever since the 1960s he has maintained a studio in both London, near the Elephant and Castle, and New York.

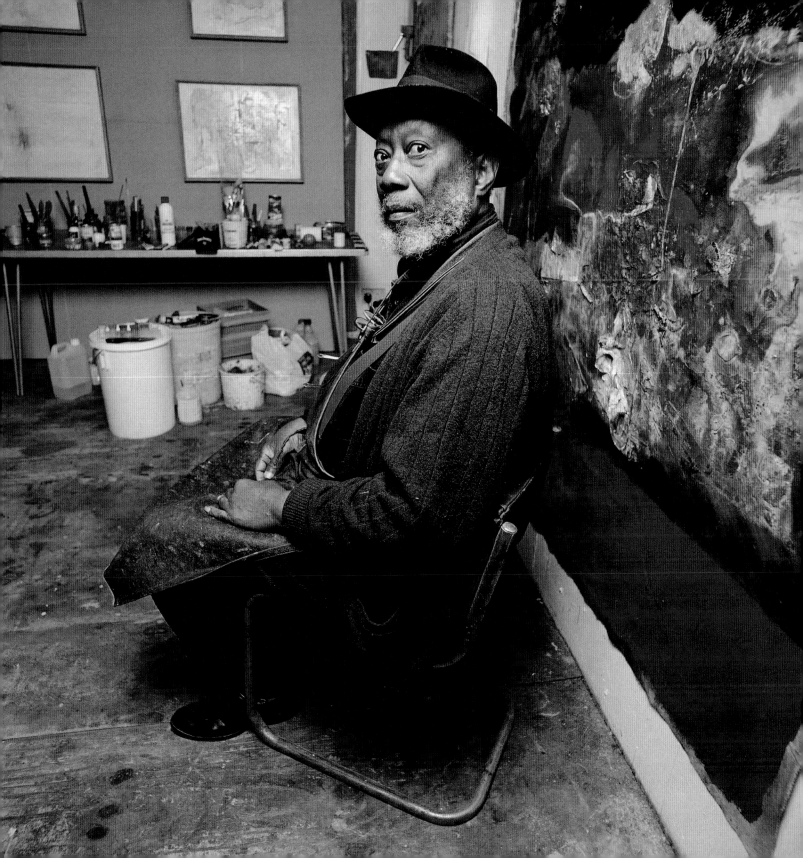

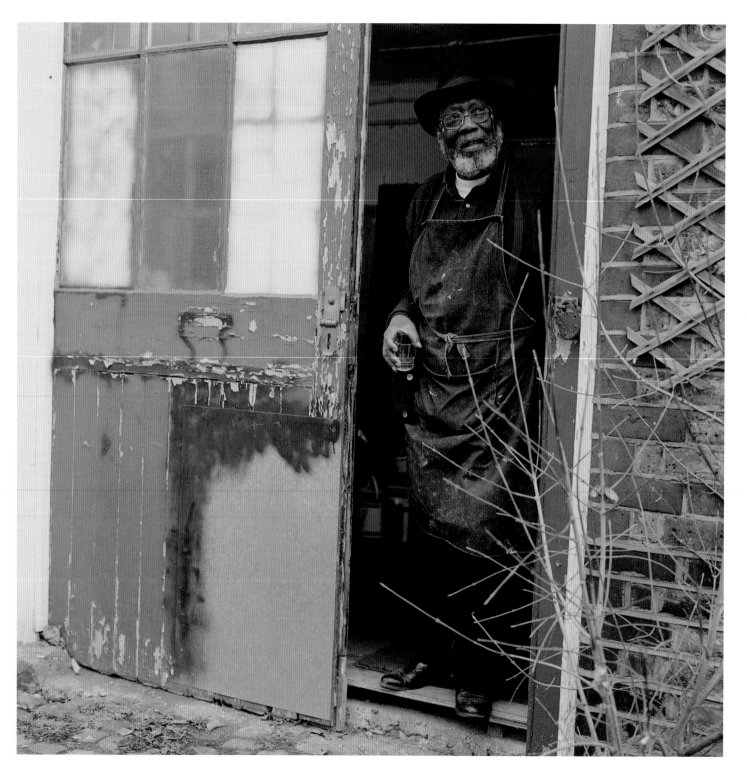

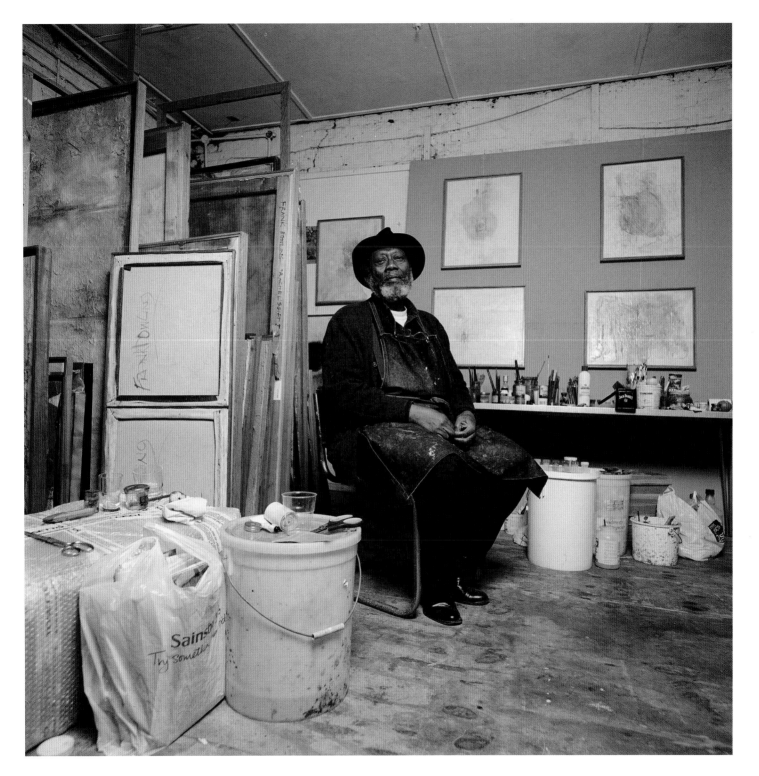

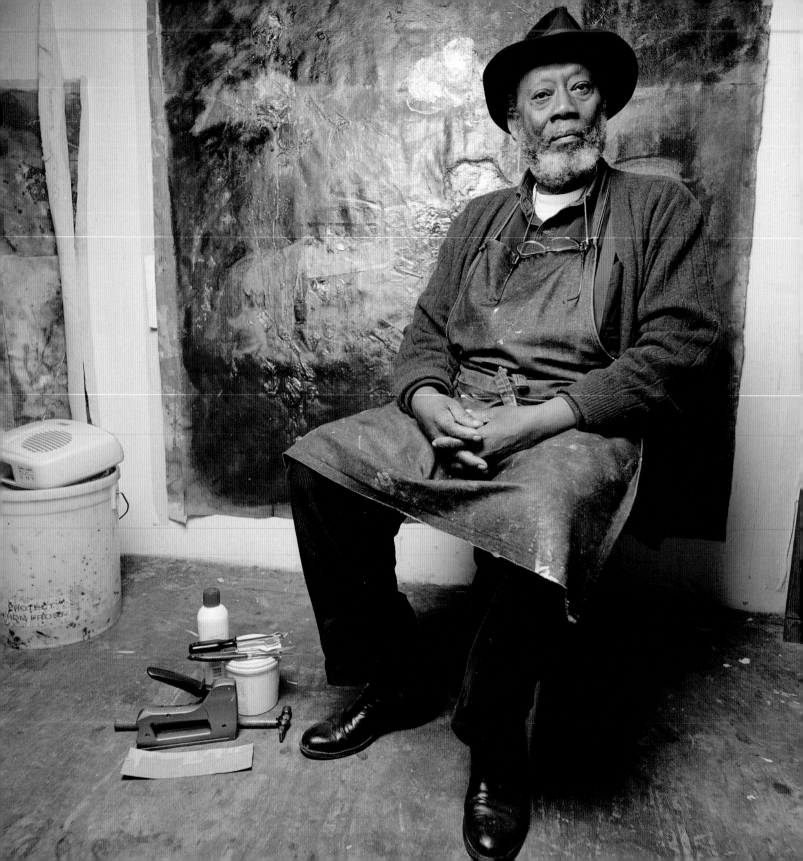

In America he switched to water-based acrylics and the earthy colours of his earlier work vanished to be replaced by a light-filled, high-keyed palette, though palette isn't quite the right word for paintings which were often made by pouring pigment on to the canvas spread, Pollock fashion, on the floor. It was no big deal when he became a Royal Academician in 2005 because so many good modern artists had accepted election over the preceding years, but he was the academy's first black artist, and blackness has been a theme of his work, at a guess quite deliberately, from the tropical exoticism of his palette to the silky white on black of his website. "Hot and sweet," *The New York Times* called these paintings in a review of a solo show in 2004, and it remains a handy portmanteau phrase for the sense of the colours.

"From cradle to grave the black diaspora artist is … torn by reminders of the need for revenge and a driven desperate love of the enemy"

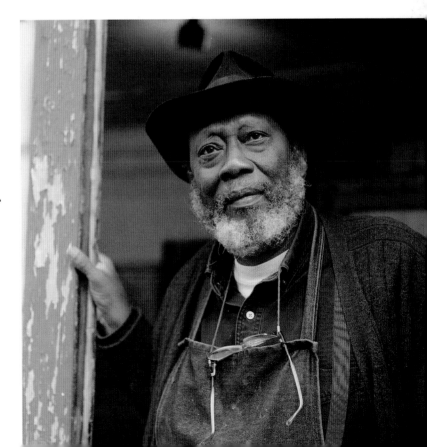

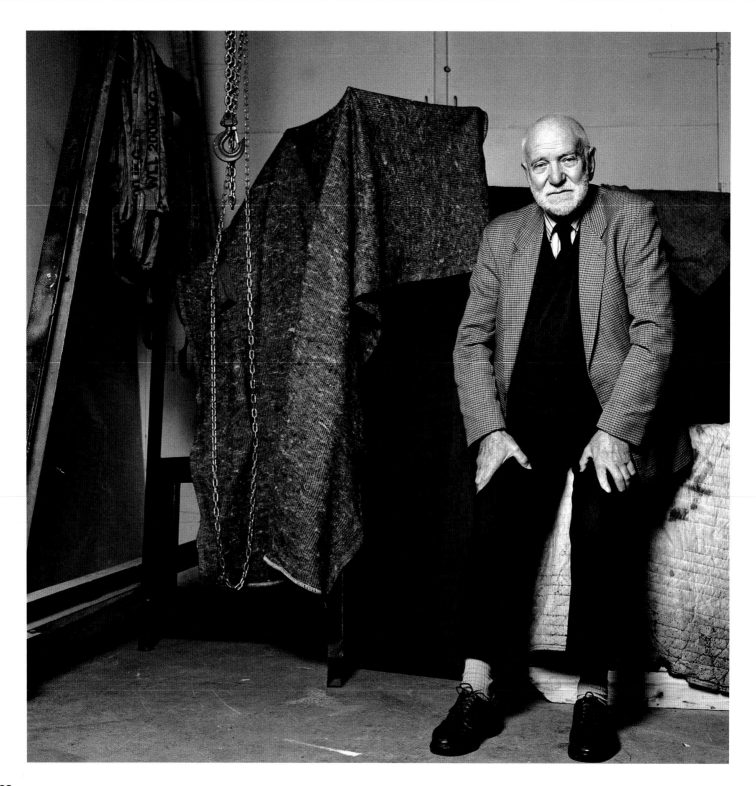

Sculpture has always been about shaping mass; more and more it has added architecture's brief, organising space. In a powerful but rudimentary form the Hepworth holes were about space that wasn't just a gap between elements of the sculpture, but an element itself. The work Caro started in the sixties with steel rods and girders went further. It was a way of outlining space, denoting areas by drawing in the air; pieces like *The Window* (1967) and *Sun Feast* (1969-70) could involve tons of heavy metal, but they constitute definitions of the lightness of being: *Early One Morning* (1962) is a composition of I beams, rods, and a steel plate, but is so delicate it's as though it is drifting in a breeze.

ANTHONY CARO

A gantry, machinery, industrial chains, oxy-acetylene cylinders, and men busy welding: it must be the studio of the artist who has remained a more innovative sculptor than any other for half a century.

It's a commonplace to say that Caro brought sculpture off the plinth but as so often in the twentieth century, Picasso had been there before. All the same, Caro's work is different. It doesn't look like anything we have seen before, sculpture least of all. The titles don't help. *The Window* has a couple of square bits, *Sun Feast* is yellow, *Early One Morning* red; that's it. Caro is uninterested in preconceptions. He doesn't even work out the sculpture on paper; instead a couple of assistants move the steel pieces around for him until he likes what he sees. He does draw from life though, and his studies of the nude female show just where the swinging ellipses and encircling curves of his steel sculpture come from. Thighs fit into pelvis like pistons, a belly is shaped like a jug. Just like the sculpture, it is all about shaping forms and mapping space.

For a couple of years from 1951-3 Caro worked for Henry Moore, who would do criticisms of his drawings. Some time after Caro left to make his own way, and doubtless as part of breaking free, he remarked: "In his [Moore's] later works it sometimes appears that he is affected by a consciousness of his greatness." Now that Caro is in his 80s, it is tempting to apply those words to his own late work. There's a piece based on the great Rubens Deposition which Caro presented to the chapel of his old college, Christ's, Cambridge. It's ingenious but seems to strain for an effect beyond Caro's compass. Well, I didn't catch up with his first breakthrough for a while, so probably I'm out of step again.

Jasper Johns's first big idea was the American flag. He painted it in 1954-5, filling the canvas top to bottom, end to end. Forty eight stars, seven red stripes and six white. But it was a painting, not a flag, the pigment applied with a painterly touch, a subtly broken surface, picking up and reflecting the light: he worked in encaustic, a medium used by the ancient Egyptians and long neglected but which suited Johns because he could scratch into the pigment and buff up the surface like a varnished table. He exhibited it in his first show at Leo Castelli in New York and Alfred Barr, the man who made the Museum of Modern Art the greatest modern art gallery in the world, immediately bought it for the collection. Johns emphasised the point that a painting of a flag is not a flag any more than a landscape is a

JASPER JOHNS

His utterances are as cryptic as haikus and all the critics of his later work are left with a sense of inadequacy in trying to convey what it's like. At a guess he is happy with that.

field, trees, and a river: he emphasised this by painting the flag in green, black, and orange or in dark grey and light grey. And then he painted the map of the U.S. like a piece of abstract expressionism and an abstract expressionist painting with the names of the colours carefully stencilled on to them.

This is the Jasper Johns most people know, the ironist, the successor with his friend Robert Rauschenberg to the mantle of the greatest living American artist just when New York needed a new all-American hero. He went on to make sculptures of beer cans, cast in bronze, and a used can adapted to storing an artist's brushes. But though these are ordinary everyday objects which he painted objectively in all their objecthood, and even though he is in books about Pop Art and is still exhibited among the Warhols and Lichtensteins in public collections around the world, he has never been a Pop artist. When he gives interviews he composes answers as elusively shadowed as Delphic utterances and as cryptic as haikus. The art, he insists, is its own justification and is only about and for itself. His imagery has become stranger, drawing on references to Leonardo, Grunewald, Holbein, his own past work; it is difficult to comprehend and all critics of the later work are left with a sense of inadequacy in trying to convey what it's like. At a guess Jasper Johns is happy with that. He is an unmarried loner working in an out-of-town studio in Connecticut cut off from neighbours, and probably means to stay that way.

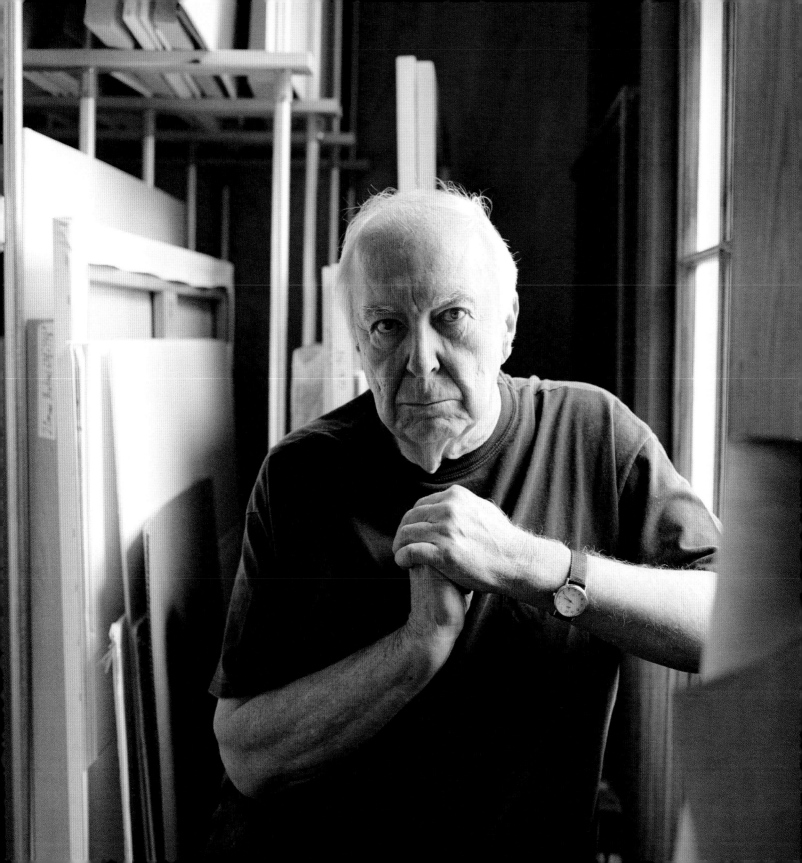

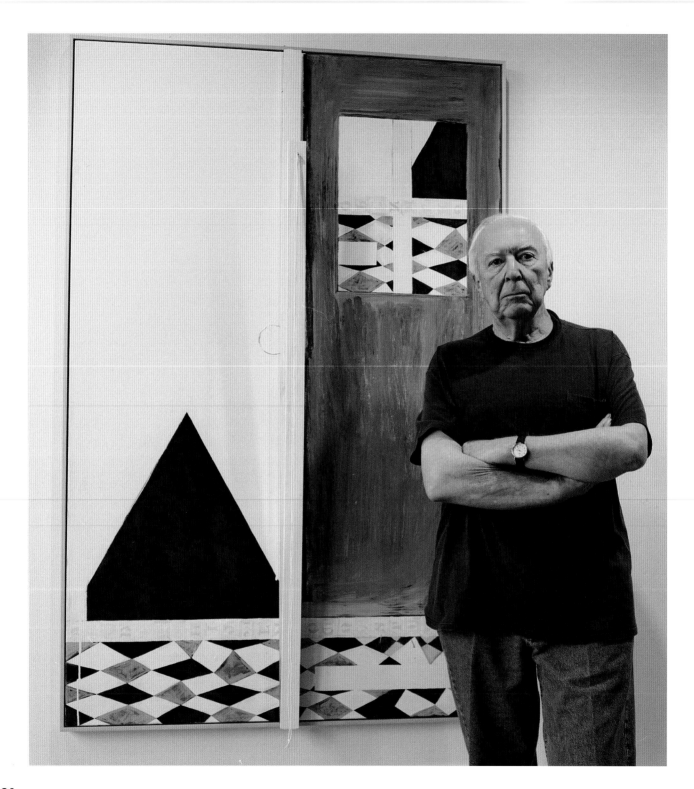

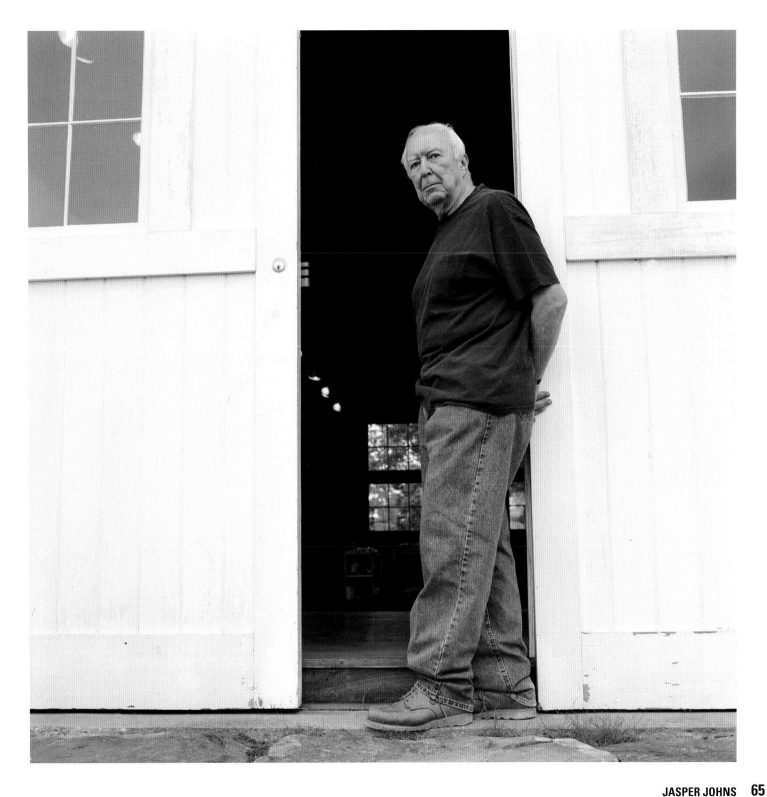

The tycoon in the photograph might have just hatched out from the chrome steel coloured egg. He's called Jeff Koons, such a neat, shiny chrome steel name that you wonder about the truth of it; we'll just have to take his word. Anyway, the heartwarming story begins with "Jeff Koons" working as a Wall Street commodities broker until his art became famous in the 1980s, and then on the proceeds he was able to sell his work for less than it cost him to produce; in legendary fashion, he robbed the rich (himself) to sell to the poor, though it doesn't seem likely that the poor included people quite as poor as the drop out reflected in the shiny egg. Does Koons even know the drop out is there? You bet.

JEFF **KOONS**

The art market loves him, and he is taking over the world with his toys. But 'found object' takes on a different meaning when it's a dollar sign: what else does Koons's work signify?

Koons knows just about everything to do with his art. It's an art of appropriation and kidology: appropriate a bit of Duchamp, a bit of Warhol, concoct a philosophy, then all you need is a few complaisant art magazines and critics. Well, he's got the Gagosian Gallery which puts out such masterful vacuities as "Jeff Koons' artworks rarely inspire moderate responses, and this is one signal of the importance of his achievement", and publications like *Modern Art* line up to print pages of his pronouncements in large display type without commentary, some of which go ahead of the works, so when you come across his exhibitionist sexual activities with his ex wife, the porn queen Cicciolina, somewhere he will have justified it as truth telling, probably one of those Dada tags about anything available is art if the artist says so. Meanwhile Koons is taking over the world with his toys, a tied balloon puppy in shiny coloured steel dominating the Grand Canal in Venice one year, another puppy forever in Bilbao, so big it blocks the view of the Guggenheim Museum. No doubt about it, the boy's done good.

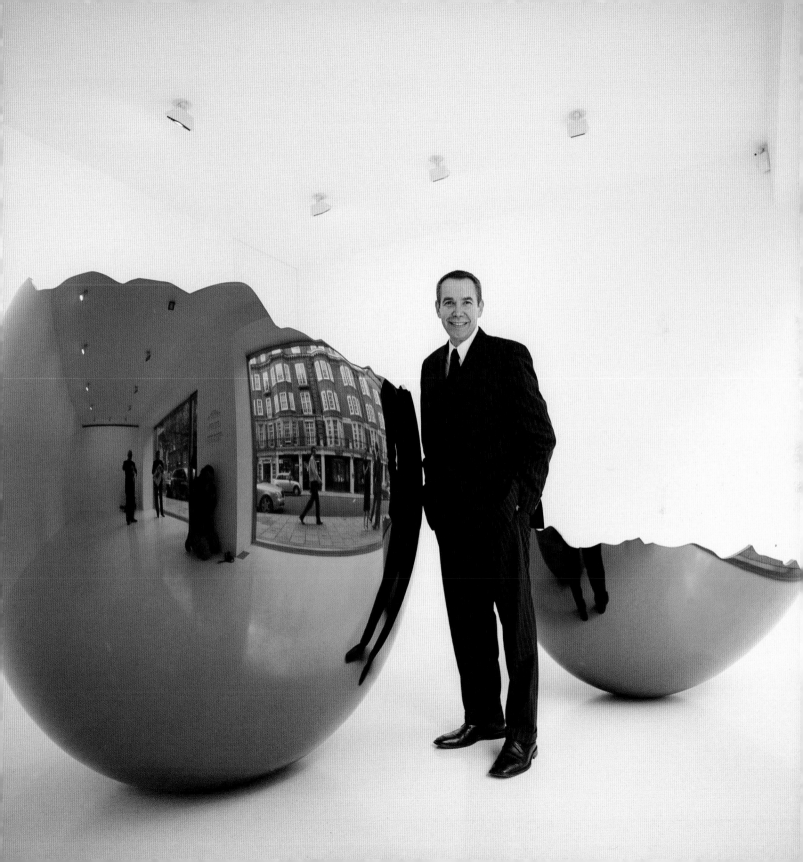

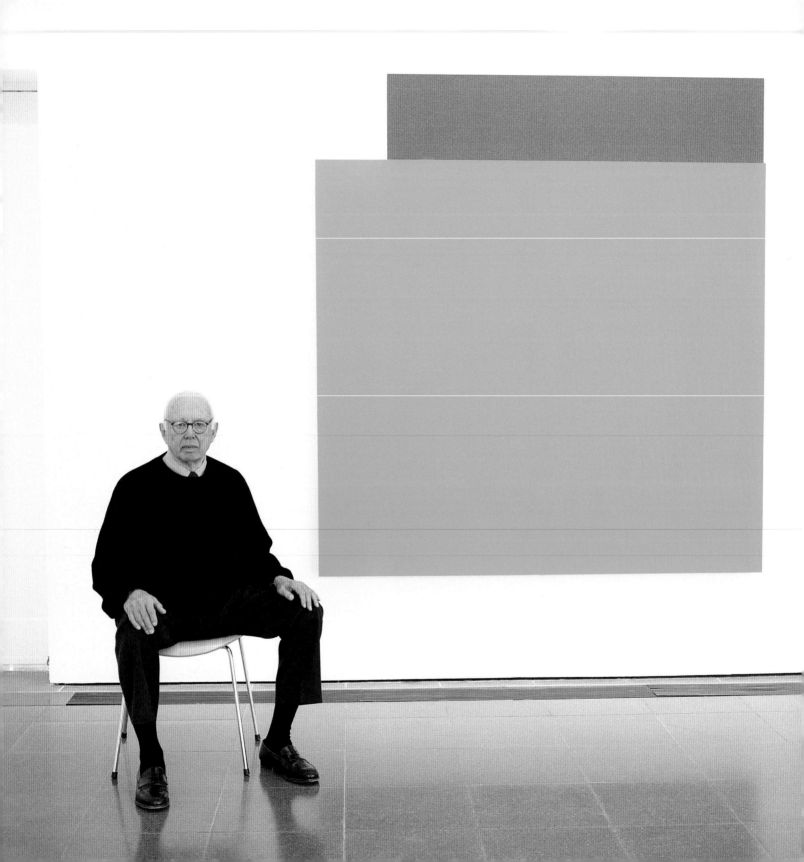

Hard-edged abstraction, which Ellsworth Kelly still works at, was the thing so long ago (the 1960s) that today it seems in prospect almost quaint; until you see it again. Kelly is well into his eighties now, the grand old man of abstraction. He started on his exploration of colour fields while the Abstract Expressionists were in their pomp and is the sole survivor of the generation of abstractionists that followed Pollock, Kline, De Kooning, and Rothko and still pursues the holy grail of painting stripped to its bare essentials, colour and shape. For Rothko, colour was drawn from the depths of the artist's psyche. For Kelly, colour is colour; paint only paint.

ELLSWORTH **KELLY**

The grandeur of monochrome colour at full throttle has worked for him since the Sixties, and goes on working.

He tends to paint separate canvases each with a single colour and then organise how they will hang together. He doesn't show often in Britain, and when he does the only real difference from the time before will be the way he displays his work: once, he used to hang two canvases as a unit in an inverted L-shape; in 2006 when he exhibited at the Serpentine Gallery and then Tate St. Ives, he would take, say, a yellow canvas, a bright orange canvas, and a lime green canvas and hang them one above the other in that order so that no single colour dominated either of the others, but each affected the other: doing to pointillism on a gigantic but restricted scale what Roy Lichtenstein did to the broad pixelations of comic book colour cartoons.

Kelly served in the war and like other artists of his generation benefited afterwards from the provision of the GI Bill of Rights that enabled him to live in France from 1947. Two things principally affected him there: he was fascinated by how the masons who made Romanesque carvings adapted their work to the irregular spaces available on and around arches and corbels; and he met Jean Arp and began, like Arp, to make abstract shaped wood reliefs. In 1954 he returned to New York and pushed into the exploration of flatly painted canvases that he has persisted with. His work has retained the architectural grandeur and inexplicable resonances of undescriptive colour given full throttle.

In Paula Rego's painting *The Policeman's Daughter* a resentful young woman cleans her father's jackboot with one hand shoved deep inside it. Up you, her resentful expression says. She is being both obedient and rebellious, and it is an autobiographical tale. As it happens, Rego loved her father, the liberal owner of a precision instruments factory, but like all Catholic girls in the Portugal of her childhood she was brought up to respect and obey men. The militaristic dictator Salazar stood in for her father as a male hate figure; she called an early painting *Salazar Vomiting the Republic*. Her husband, Victor Willing, was both lover and dictator.

PAULA REGO

Posing for her photographs, the artist borrows plumage from the exotic collection that transforms her Camden Town studio into a backstage costume department. But when she paints, even her little girls have murder in their eyes.

She met Willing in 1956 while they were both studying at the Slade: he was already regarded as the best of his generation of painters in England (born 1928, seven years before Rego). What he told her to do she did, even if it meant repainting a picture. And when he took twenty two years over dying (in 1988 of multiple sclerosis), she took twenty two years to nurse him, painting infrequently, feeling unable to compete; resenting him, loving him, needing his criticism because he more than anyone knew what she was about, sometimes even before she did. He was already married when she met him. When she became pregnant she went home to Portugal to have the child. She had already had one abortion, and when her father now said she could lose this child too, she refused. Later the topic became central to her painting when, inspired by the failure of a referendum in Portugal to legalise abortion, she created the powerful abortion paintings, a sequence of primal suffering and shocking animality.

Rego's family lived in Estoril and her nursery from the age of five looked out across green trees and a little fort at the blue ocean, but she looked inwards, drawing on solitariness. In old age her childhood in Portugal becomes an ever more intense reality to her, but one which she handles best from London. Her studio moves around with her inside her head, and even in the big space that is her actual studio, sparsely furnished with a table bearing containers of gouache, a sofa for models, the odd canvas stacked against a wall, a trolley, she might as readily be discovered crouching on the bare floor painting as working at an easel.

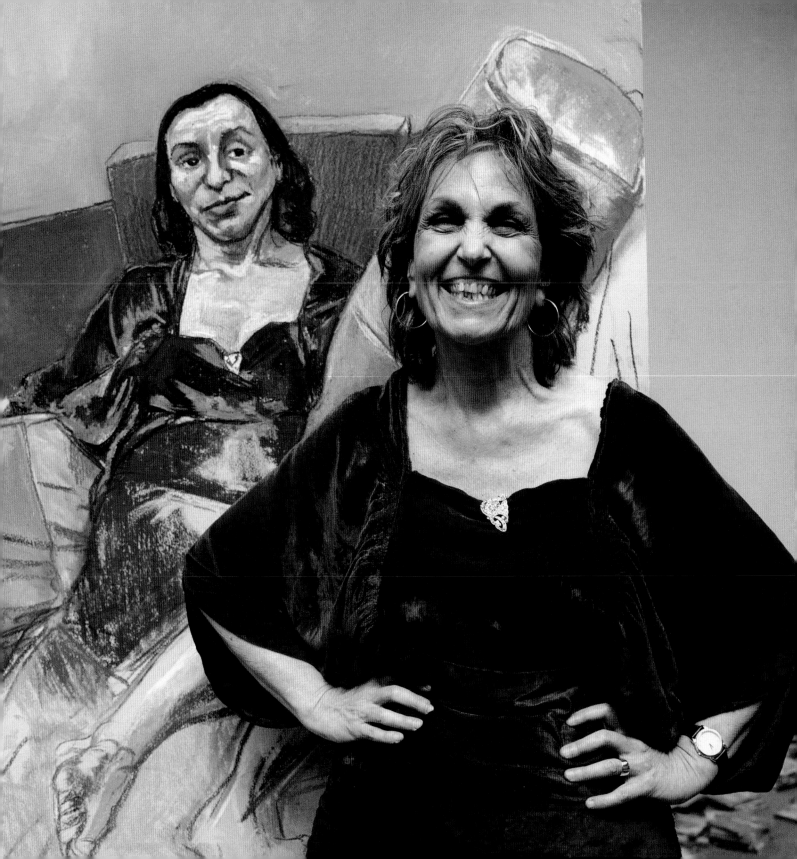

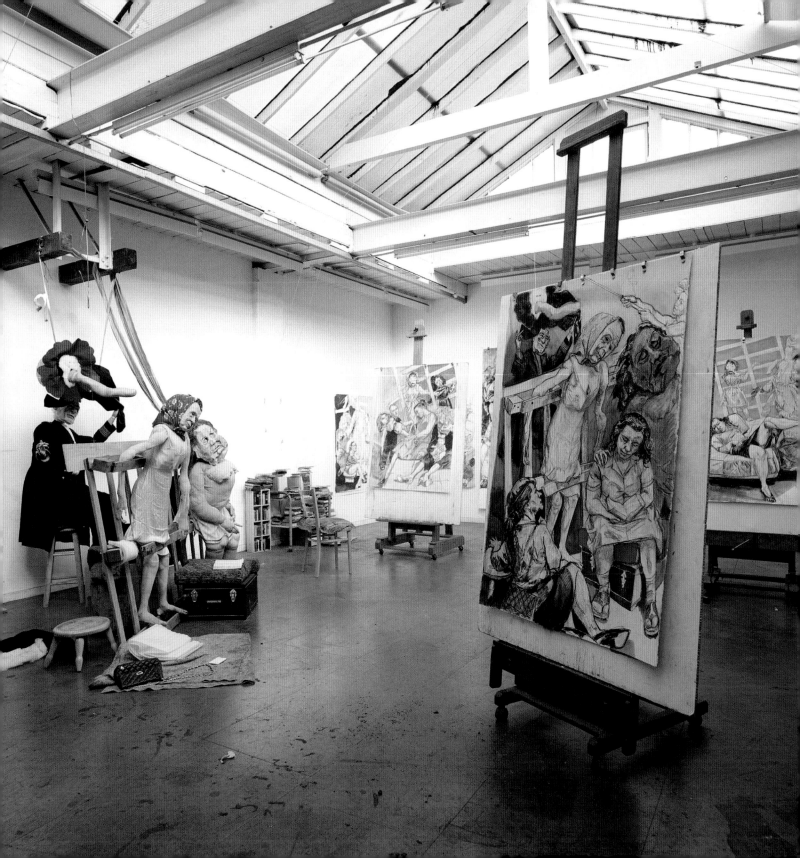

Like Degas, Rego has taken to pastel, for its urgent physicality, for the speed with which passages of work can be reformulated. It's drawing, but it is as complete as a painting. Like Degas she took ballet dancers as a subject, the sweating athletes of the rehearsal room and the wings, not the glamorous visions of the spotlit stage. Both artists show the dancers as working women, but Degas looks with the objective interest of the male artist, Rego with passionate identification. Someone asked her why she hardly painted men in her pictures. I do, she said, pointing to a figure in one canvas. It was a dog.

But she was not scoring easy points. The dogs in her paintings are being petted or groomed or fed by little girls who look as though they have murder on their minds. These men/dogs look puzzled and anxious, the way dogs do when they're not sure what you want of them; but then there are women/dogs, actual women in dog-like postures, un-house trained, awkward, resentful. The animals in her work started as toys in her nursery and grew pretend lives like the wild things of Maurice Sendak's nightmarish children's books, but unlike Sendak's, brutal parodies of human life, especially a series featuring a red monkey who gets drunk, beats his wife, vomits while his wife cuts his tail off with a vicious pair of scissors, and generally behaves like our best friends.

Rego's work has hardly made a ripple in the United States, probably because despite its power it demands to be taken on its own terms; it serves no modern art agenda. But the house of art has many mansions; the true word for hers is "subversive", sublimating on canvas the hurts and wrongs inflicted on women and ignoring the art world agenda.

"In the pictures and drawings you had the freedom to do whatever you wanted. You could be destructive and violent: in particular, violence, which is very important"

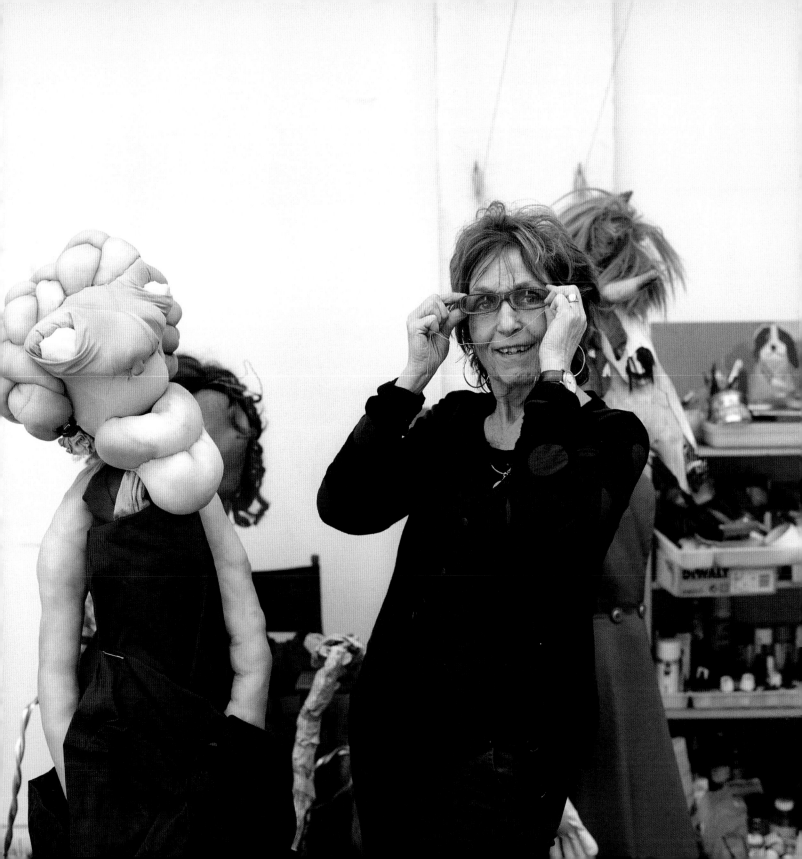

His first sculptures are soft, often coils of rope and canvas and jute sacks part filled with sand with comically attenuated protuberances like hesitant antennae. They look like provisional forms of life, already lilting but not yet sure what their role is. It seems that they need Barry Flanagan to come by and wave his wand. Abracadabra: the soft toys become hard bronze, electric hares, lean quadrupeds, lithe acrobats slicing the air like lightning, boulevardiers, satirists striking poses like the grandees celebrated in city centre statuary. They are

BARRY FLANAGAN

Recently he has returned to abstraction, but the hares are still around, like floppy-eared versions of Brancusi's Everlasting Column. It's sculpture as fun, and Dubliners take them to their hearts.

jugglers and musicians. They are artists; one bronze is called *Whistler's Brush*, and the hare, his limbs coiled springs, insouciantly swings the brush like a flaneur's cane. Or readymade masterpieces like the profoundly pondering quadruped posing as Rodin's *Thinker*. Another is called *Cricketer*, but he is more attention seeking streaker than sportsman as he struts on top of a pyramid of three stumps; it's in his nature, after all, to streak off hotly pursued. Hares leap into action, feet on head, hand on hand, forming perilous towers like wriggling, living, floppy-eared versions of Brancusi's *Everlasting Column*. It's sculpture without the mass and density, sculpture as fun, sculpture as essence.

Flanagan's hares travel. They take their bow at public appearances in Park Avenue, New York, and St. James's, London, at the seaside in Japan, in the city of Ghent and on the Champs-Elysées. When they turned up in 2006 lining O'Connell Street, to celebrate the reopening of the Hugh Lane Gallery, Dubliners took them to their hearts like unpredictable old friends. Maybe nobody's mentioned that, despite his name and current home (Dublin), Barry Flanagan was born in Wales and the gallery that has promoted him successfully across the world is the Waddington in London. He learned about bronze at Birmingham School of Art, but student budgets as a rule don't run to casting in bronze, and that's how matters stood when he graduated from St. Martin's School of Art in London in 1966 and had his first show (of floppy sculptures) at the then pre-eminent Rowan Gallery. But in 1969 when he was teaching at the Central School of Art and Design he made a bust of his father in law and had it cast in the school's foundry. It impressed the head of sculpture, Henry Abercrombie, who soon afterwards became a partner in a bronze foundry and invited Flanagan to come

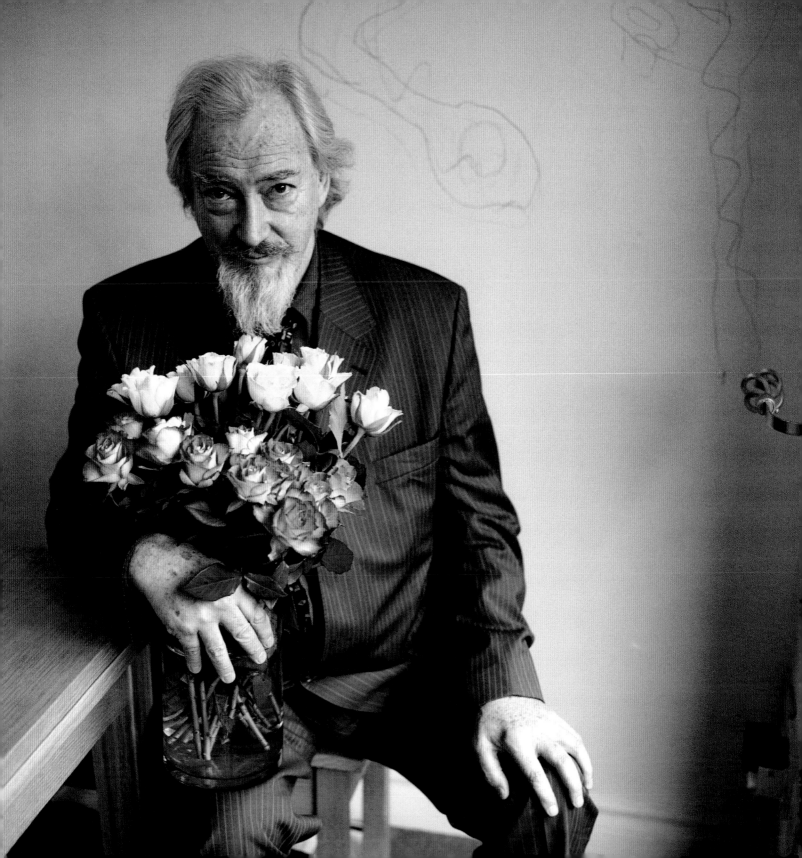

along and try his hand. Already at college he had, not uniquely for the times, followed the drum of the French absurdist Alfred Jarry, a precursor of surrealism, author of the nonsense play *Ubu Roi*. It was the harebrained philosophical underpinning Flanagan needed.

Actually, he has modelled other animals as well, including a hound, the hare's natural enemy, and an elephant with a cougar riding mahout on his back (a piece called *Unlikely Alliance*). The elephant is as phlegmatically immovable and solid as the hares and cougar are firecracker fast, but he treads daintily on a base that might be the whole world, or it might just be a circus drum. And the pair are as lightsome as anything in Flanagan's work. Are the inhabitants of the menagerie the artist's other self? Absolutely. Flanagan told the *Irish Times*: "The idea of the hare as an alter ego evolved. It wasn't inevitable when I started. But once you abstract from the human like that, it opens a window in the mind, it allows your imagination to roam." What's also certain is that Flanagan's talent is rooted in drawing. His animating line describes outlines like sacks but turns into nudes as edgily observed as Degas', taking their colour from the paper with maybe a saturating splash of vermilion defining a stockinged leg; but he might simply describe a circle and a square on paper and already he has created a vibrant life form.

Recently he has returned to abstraction, notably in a piece in Lincoln's Inn Fields called *Camdonian*; it is sculpted from sheet steel and the meandering line left as sections of steel were cut away is the defining contour of what's left but also, at least as importantly, of the space between contours. Mind you, the hares still pop up, keeping a lively eye open.

"I am no great intellect. I took up a trade, in the bronze shop. And I've proceeded as any trader would"

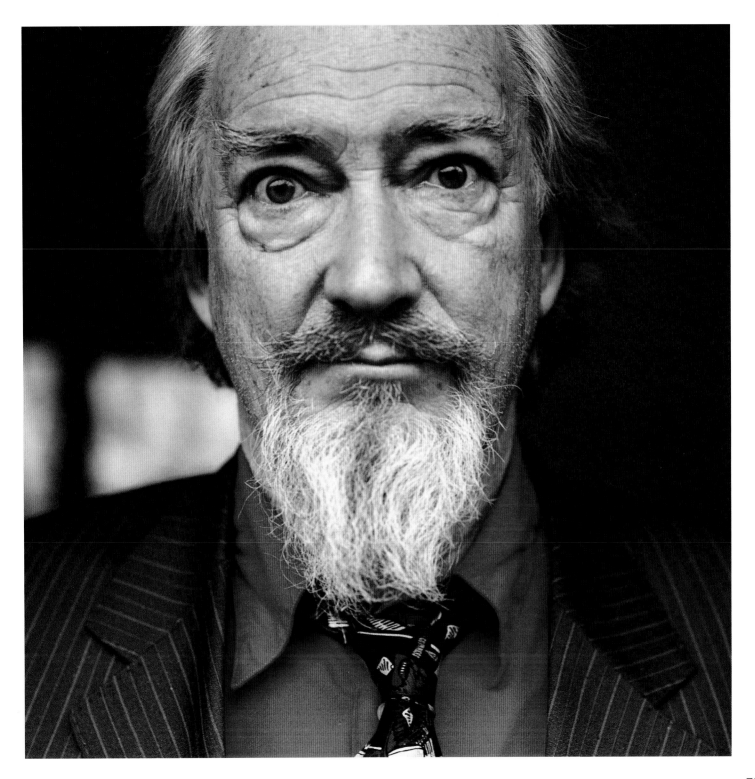

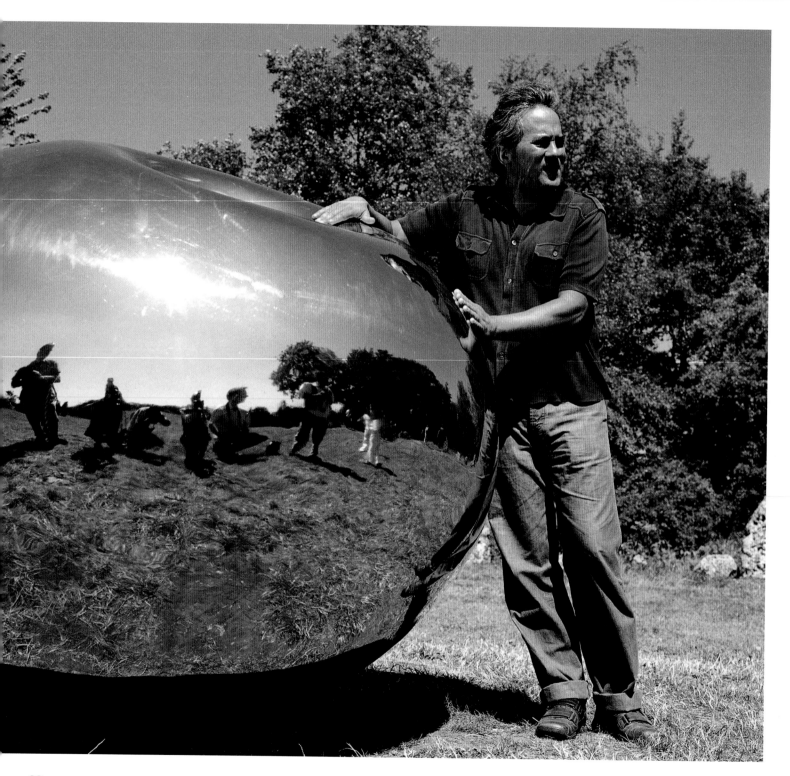

I am looking at the photograph of a piece on the Tate website called *Adam*. It's about eight feet high, is by Anish Kapoor, and it looks like a roughly shaped block of sandstone straight from the quarry. The discomfiting bit is a rectangular patch of blue pigment: is it painted on to the surface, or is it in an indentation in the rock? I am bearing in mind that I approached another piece in Tate Modern once to stroke a patch of lush dark velvet and found myself instead putting an arm into a hole. Kapoor's theme is oppositions, polarities: mass and void, rough and smooth, darkness and light. Especially darkness; it's the darkness within that fascinates him, as symbol, as physical fact, and, presumably, as a product of his fifteen years in analysis after a severe emotional crisis.

ANISH **KAPOOR**

He started with little piles of primary coloured pigment, like something from Yves Klein's palette, or the bazaar of a holy city. Now he makes massive pieces in burnished steel, but it's the same difference.

So mirror surfaced steel, impermeable, inexpressive, industrial, seems a contradiction as material for his sculpture; but Kapoor's *Turning the World Inside Out*, placed for a while in the centre of the prehistoric Rollright stone circle in north Oxfordshire, looked as though it had alighted overnight, shining implacably, reflecting the sky and the trees, a twenty first century object with anthropological overtones as suggestive as the Neolithic menhirs, and as impossible to read. The piece actually belongs to Cartwright Hall in Bradford, and of course mirror surface steel sculpture works in cities as well, notably among the Chicago skyscrapers, where the immensely popular, immensely expensive *Cloud Gate* (either $23 million or $25 million to install, according to who you speak to), 33 feet high, 66 feet long, weighing in at 110 tons, holds its own by the encompassing beauty of its presence. It's a female presence; like all Kapoor's work it is to do with the female principle: vaginas and wombs, never the phallus.

Kapoor's early works, which look like shaped piles of finely powdered pigment, could be something exotic out of a bazaar in a holy city, but one of his influences was the artist Yves Klein, a specialist in single colour works and inventor of what is still known as Klein blue. Kapoor, in fact, is never that easily placed. He was born in India, but is Jewish and has lived most of his life in England. So while the influences are multiple, art is increasingly indivisible and his work is never a stranger whether it's in Gateshead, Ottawa, or Tokyo.

The statue of Alison Lapper that occupied the fourth and empth plinth in Trafalgar Square for a couple of years earned its sculptor, Marc Quinn, plenty of brownie points, especially from Ken Livingstone, the mayor of London, who said: "It is a great work of art for London and for the world." Well, it was big, but it wasn't great. Quinn showed Lapper, who was born armless, naked and eight months pregnant, beautiful and proud. The trouble is that the sculpture, carved from stone hewn from the quarry of the gods and Michelangelo, looks as though it was created not from Carrara marble but from a gigantic bar of Lux soap. As the studies pinned to the wall behind the artist show (above and right), Quinn is highly gifted, so what went wrong? The modern way was to renew the sculptural tradition by absorbing the lessons of pre-Columbian art, African art, Iberian art, Romanesque art. Quinn decided logically enough to take on ancient classical western art and reshape it. He uses the stone of Praxitiles and shows how pristine and shiny it was way back when, and how the subject matter can be renewed by rethinking classical norms as something relevant to the realities of modern life (see the photos pinned up behind his head). That's fine, but the reality of the art is that ancient sculpture was never simply a flat assertion of identity, nor were the surfaces ever so factory shiny and devoid of incident.

MARC **QUINN**

Quinn's post-modernism means a return to the material of Michelangelo and Praxitiles, not to show man and Alison Lapper as godlike, but as tenacious against the odds. Fine, but does it fulfil the promise of his sketches?

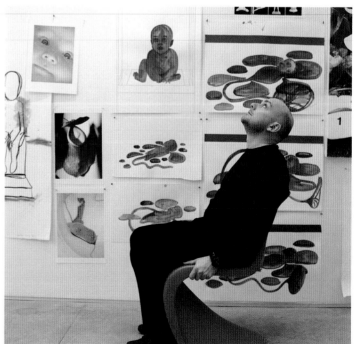

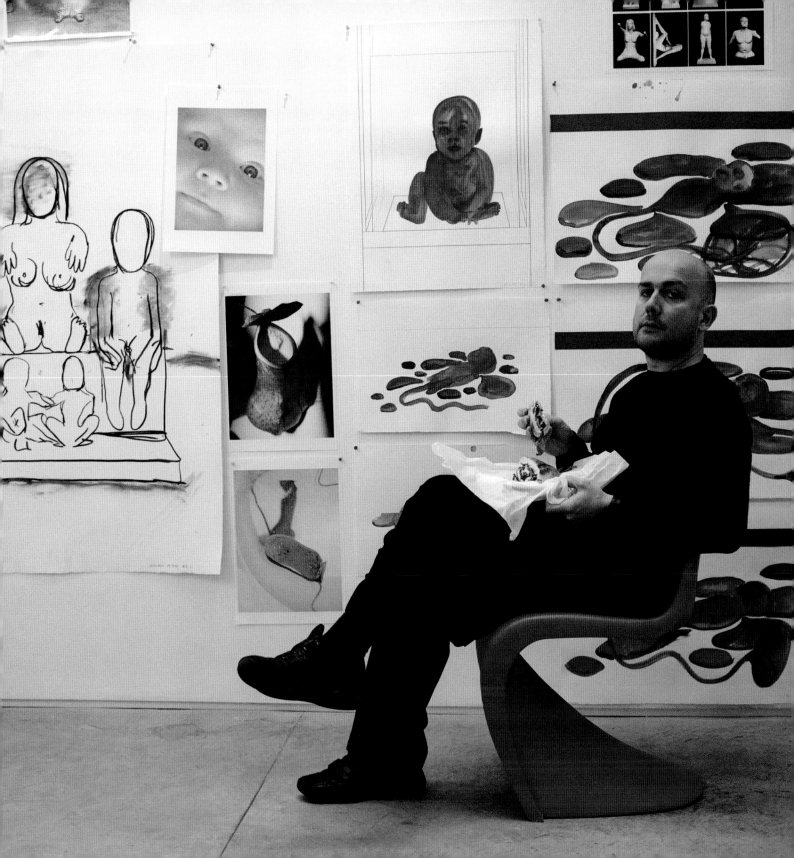

Sapper Ronald Searle, a fresh faced artilleryman, had just arrived in Singapore in 1941 when it fell to the Japanese. He pulled out his sketch pad, began drawing General Yamashita's army streaming in, on foot, in tanks and staff cars and on motorbikes, and he didn't stop until he was repatriated to Britain in 1945. He drew their conquerors and captors in Changi jail and on the Singapore–Siam railway, the death railway as it became known as starving prisoners began to drop into shallow graves. David Lean's Kwai Bridge movie set to the tune of *Colonel Bogey's March* doesn't bear much relation to the truths that Searle drew, hiding his sketchbooks except when complaisant Japanese officers and NCOs allowed him to draw their portraits, dispassionately recording his comrades picking lice out of their hair, disabled by malaria or cholera, dying and dead by the side of the railway. Searle was immune to none of these afflictions except death and, as his fellow prisoner Russell Braddon observed, "We'd have known he was dead if he stopped drawing."

RONALD SEARLE

"We'd have known he was dead if he'd stopped drawing," said a fellow PoW on the death railway. He never did stop.

Braddon published *Naked Island*, his own account of the same experiences, in 1952; but it was 1986 when Searle felt ready to publish a book of the prisoner of war drawings (*To the Kwai and Back*) and present the artwork to the Imperial War Museum, where they constitute a remarkable documentary record. None of the paintings in the museum, of first or second world war, stand up to Searle's objective record. Fine art falls between disciplines when it attempts to be an instrument of record: the great Georges Braque, who served with distinction on the western front until he was invalided out of the army, insisted on the difference between what he called "anecdote" and "pictorial truth", and returned to Cubist still lives rather than become a war artist. Searle had no pretensions to fine art and this liberated him to leave a legacy of, effectively, pictorial journalism.

After that he earned a living drawing cartoons for *Punch*, *Lilliput*, and the national press and his advertising work for Lemon Hart rum, massively enlarged as poster ads in the London underground and in neon lights in Piccadilly Circus, lit up drab post-war London. His first *St. Trinian's* cartoon appeared in *Lilliput* when he was already a PoW. After the war they were collected in several books and made into a series of films produced by Frank Launder and Sidney Gilliatt. He made a reputation as a topographical artist and collaborated on several travel books. And he did covers for *The New Yorker*, the acme of the profession for a graphic artist.

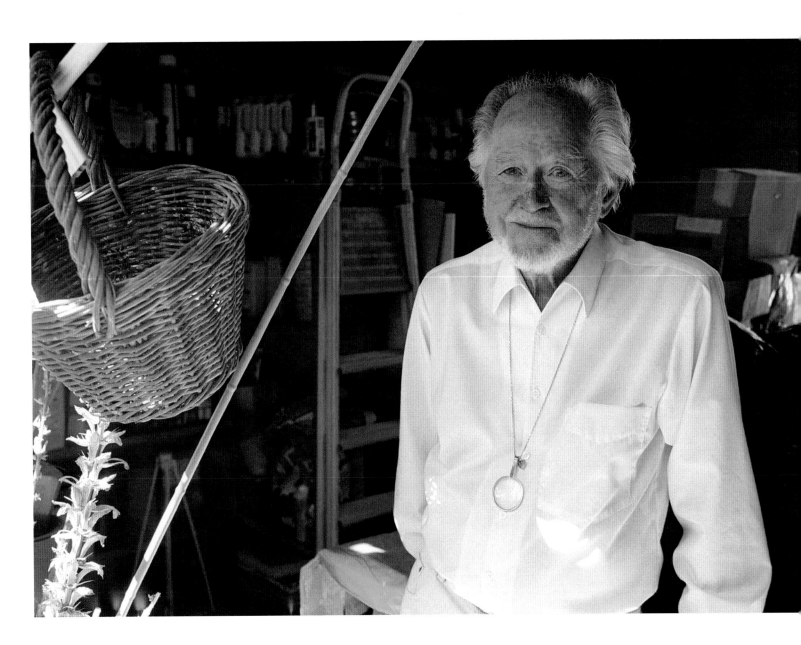

Blake is the old master of art for kids, or children's laureate as he would surely be if it were awarded for life instead of just a two year stint – he was the first, appointed in 1999, when it was set up by Booktrust after a conversation between the children's writer Michael Morpurgo and the grown-ups' laureate Ted Hughes set the ball rolling. His line is a supple instrument, usually comic, and not always for children: he is, of course, an illustrator at large as well, and though his formal education was offbeat for an artist – he read English at Downing College, Cambridge – he was head of illustration at the Royal College of Art from 1978 to 1986.

QUENTIN BLAKE

He gives away his trade secrets in a manual called Drawing for the Artistically Undiscovered. Pencils are supplied in an attached zip-up case.

He's best known for working with Roald Dahl: illustrations for *Danny the Champion of the World*, *Charlie and the Chocolate Factory*, *The BFG*, *James and the Giant Peach*, and on and on; though it was with Russell Hoban that he won the Whitbread Award for Children's Books in 1974 for *How Tom Beat Captain Najork and His Hired Sportsmen*. Some of the best are those he has both written and illustrated, and not just because in them he gives the illustrations pride of place. Among these is the wonderful *Cockatoos*, which gives full expression to Blake's exuberant colour as well as line. It's about a Professor Dupont and his conservatory full of cockatoos, which get so fed up with the prof coming in every morning and saying "Good morning my fine feathered friends," that they decide to play a trick on him by distributing themselves around the house, hidden under pyjamas in the bedroom, among the flowers in the vase on the dining room table, behind suitcases in the attic, on top of the lavatory cistern. It is, of course, a counting book as well as a comedy and a social commentary (lovely detail of Professor Dupont's richly furnished house).

He gives away his trade secrets in another terrific kids' book, this time a manual called *Drawing for the Artistically Undiscovered*. Pencils are supplied in a zip up case attached to the book. Children, naturally, supply the genius.

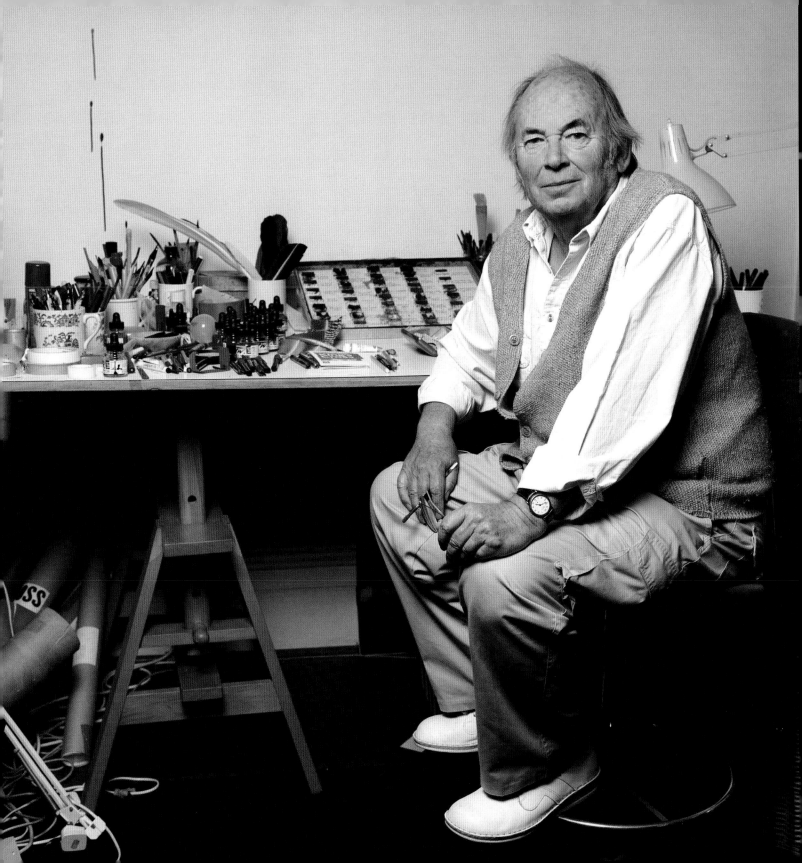

Being born in Eastbourne seems to have been a good career move for an artist who likes to portray old folk, people with lived in faces. When the six presidents of the British Academy commissioned a group portrait, Stuart Pearson Wright gave them not only their own wrinkles but a plucked chicken as well, because the wrinkled skin reminded him of old age and the bird served as a memento mori.

The painting earned him £25,000 as the winner of the 2001 BP Portrait Award, which Pearson Wright received, not with the usual bromides but with a sharply worded attack on the Tate for failing to support young figurative painters.

STUART PEARSON WRIGHT

The images of masturbation are based in a rootlessness comes from knowing that his mother was artificially inseminated, but not knowing who his donor father was.

Still, the award helped him to launch a career without having to working in a McDonalds, and though his website is www.thesaveloyfactory.com, the suggestion of a sausage-machine production line is a little self-irony: though there are some weightlessly amusing surrealist images on the site, the frank images of masturbation are more deeply based in the sense of rootlessness Pearson Wright lives with because he was born after his mother was artificially inseminated. He has never known who the donor was.

In 2006 he held an exhibition of portraits of actors at the National Portrait Gallery and the National Theatre; it was called *Most People are Other People*. Sure enough, one of the actors, Fiona Shaw, said she felt as though he was portraying himself while he was painting her.

"I've always been ruthlessly ambitious, hungry and driven — I knew it wouldn't happen to me unless I made it happen. I've just been fiercely active in creating opportunities for myself"

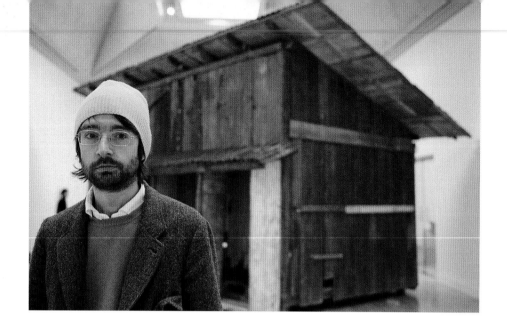

Simon Starling may always be best known for his 2005 Turner prizewinning *Shedboatshed (Mobile Architecture No 2)*, which has taken its place in pop ridicule mythology alongside the bicycle tyre skid marks on a board covered with black bitumen (William Green, 1950s) and the Tate bricks (Carl Andre, 1970s). "It's art because I trained as an artist," Starling said in an interview, faintly echoing Marcel Duchamp all those years earlier. It makes Starling sound a touch vainglorious, but he added: "Art for me is a free space to explore things," which is more like it.

SIMON **STARLING**

Starling in Tate Britain with Shedboatshed: "I'm like any artist these days working in relation to a long history of art. I think the press is a long way behind understanding this …"

All art is conceptual, but what defines conceptual art is the stuff that puts the concept equal or ahead of the finished work. In the case of *Shedboatshed*, the construction started life as a shed on the banks of the Rhine in Germany, which Starling converted into a boat, then paddled it down river to Basle, hauled it out of the water and reconverted it to a shed. To show in a gallery of course. The object isn't necessarily meant to give pleasure (but did to the woman who sent him her poem about sheds), it's meant to make us feel historical resonances, about beginnings and transformations and kicking against the traces of consumerism.

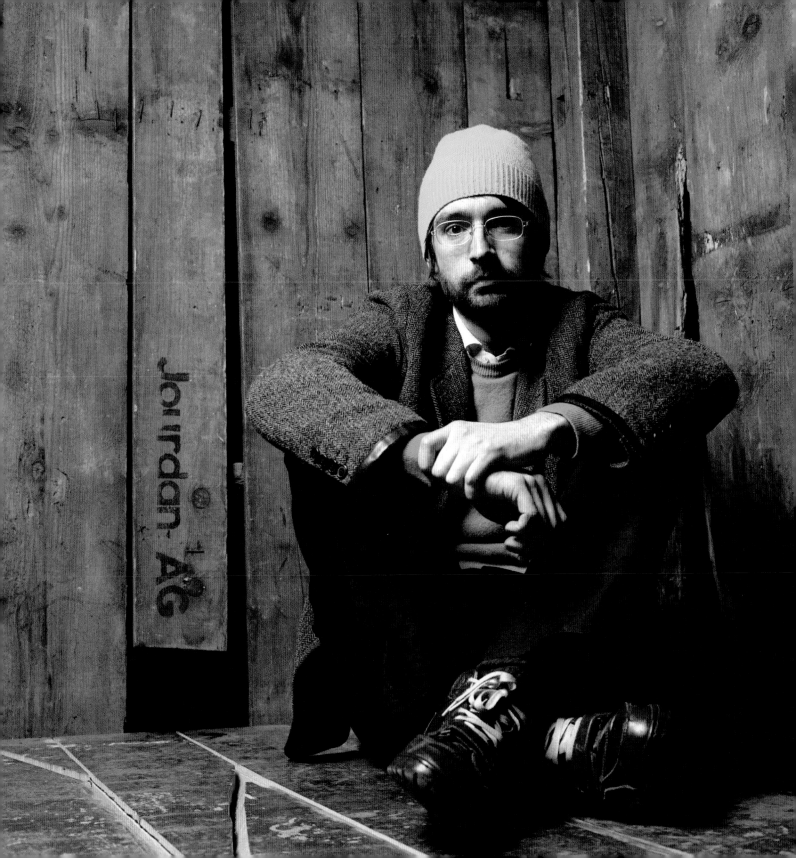

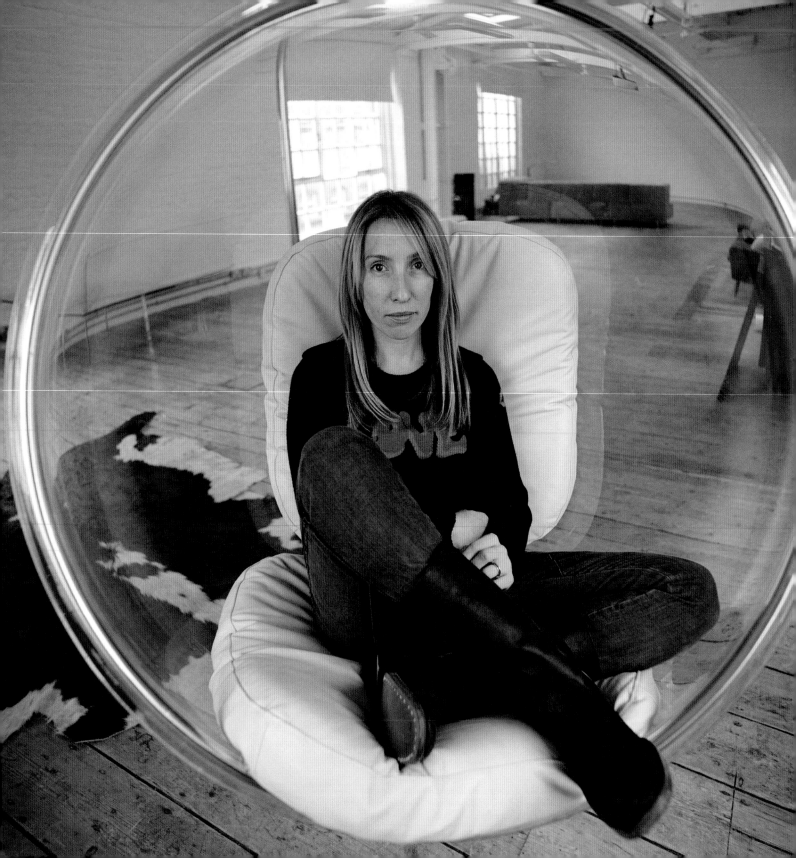

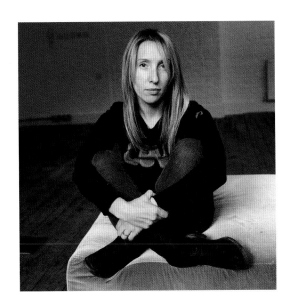

Sam Taylor-Wood's best career move was marrying her dealer, Jay Joplin, the owner of White Cube. And her worst career move was marrying Jay Joplin: through him she moved into smart society, became one of the magnificent seven of most desirable party guests, gained access to celebrities as subjects and, naturally, became a target for critics. She lined up Michael Gambon, Pet Shop Boys, Elton John, Dustin Hoffman, Jude Law, David Beckham (though as it happens the Beckham video of the great man asleep was a commission from the National Portrait Gallery.

SAM TAYLOR-WOOD

She lives in a world where reality can be more like a Vogue photo shoot than the stuff in the streets, but at its best her work turns the glossiness into a disquieting commentary on mortality.

Sure, her work is uneven; the actors crying to camera was pathetic, and not in the way she intended. You'd expect that of a young artist, but her takes on art history, from the *Rokeby Nude* to Henry Wallis's *The Death of Chatterton* and her Felliniesque panorama *Five Revolutionary Seconds* (about 25 feet wide by a bit over two feet high) are intelligent and engrossing pieces in the latest outbreak of "new realism", which, naturally, isn't realism at all but play acting at realism, consciously setting up tableaux of sexual fantasy, unfulfilment, mortality and putrefaction, all filmed glossily as though for a billboard or for *Vogue* but with undercurrents of disquiet.

As artists go, Howard Hodgkin is a toff. Not at the Delacroix level, maybe, but certainly up there with Degas. His wartime childhood was spent in a Long Island house that reminded him of Gatsby, he was taught art at Eton by a brother of the celebrated Anthony Blunt, his relatives include a Nobel Prize winner, he has made a first rate collection of Mughal paintings, the luxury of his own paintings suggest a man at ease with his lot.

HOWARD **HODGKIN**

The titles of his paintings are like coded references to an impenetrable emotional life. His canvases expand with space around them, but too often they shrink in close contact with each other, and the public.

He started quite differently, working slowly, completing only a handful of paintings each year, works that looked like schematic Vorticism with recognisable figures. Some of his colleagues from the time still regard them as his best work; certainly they are the most rigorous. But by the time Hodgkin had his first museum show, in Oxford, he was in his mid-forties and had worked through to the lush abstraction that has characterised his painting ever since. Even so, each Hodgkin painting remains rooted in a particular emotion or occasion, a seduction, a meal, a holiday, a sunset, usually something he feels deeply or an occasion that has lingered in his memory. Hodgkin signals this in his titles, and at one time the titles were indicative of a portrait or a building and certainly of the shapes drawn from them. But for the viewer the titles of later paintings might as well be hieroglyphs, coded references to an impenetrable emotional life. *In a Hot Country* or *Bombay Sunset* are certainly hotly coloured, but the titles of *Valentine, Anecdotes, Dinner at Smith Square, the Green Chateau* could be completely interchangeable for anybody except the artist himself. This really does not matter; what counts is the climate of his colours, the broad strokes of pigment on to canvas, the warmth and coolness, the radiance.

He doesn't allow anyone to see him at work, and when Eamonn went to photograph him in his studio, Hodgkin turned the canvases with their painted faces to the wall. It would be crude to suggest that he should think along those lines before he shows in public, but the fact is the more generously he endows a single exhibition the fewer favours it does him. Visiting the big Tate show of 2006 and another retrospective at the Hayward in the nineties felt like going into a house made of sweet chocolate. What Hodgkin's lush canvases need, perhaps the smaller ones even more than the late big ones, is, if not solitude, certainly space.

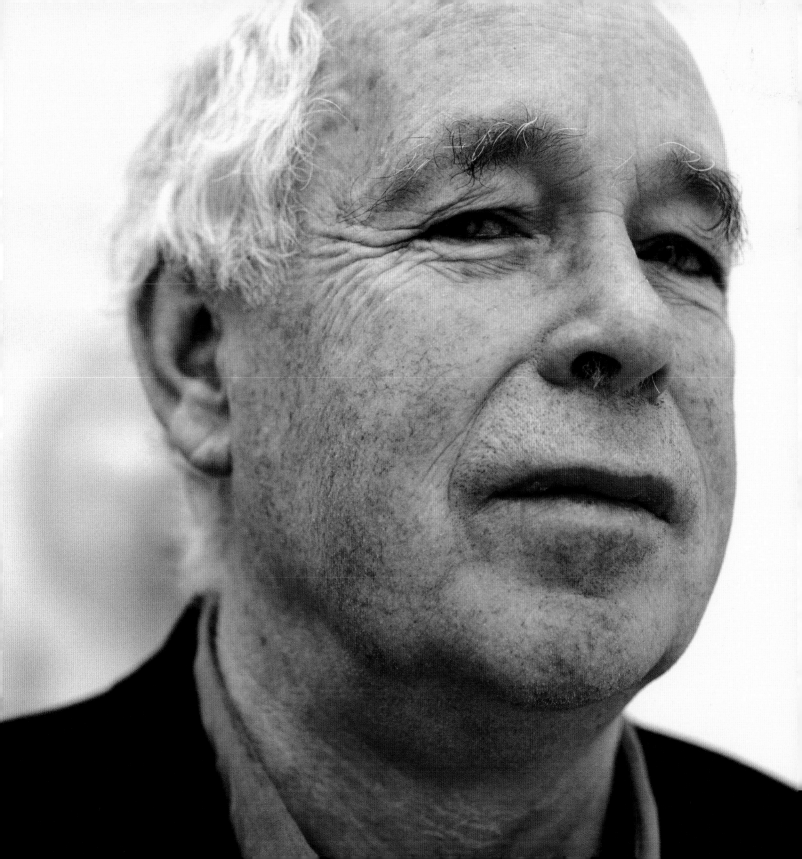

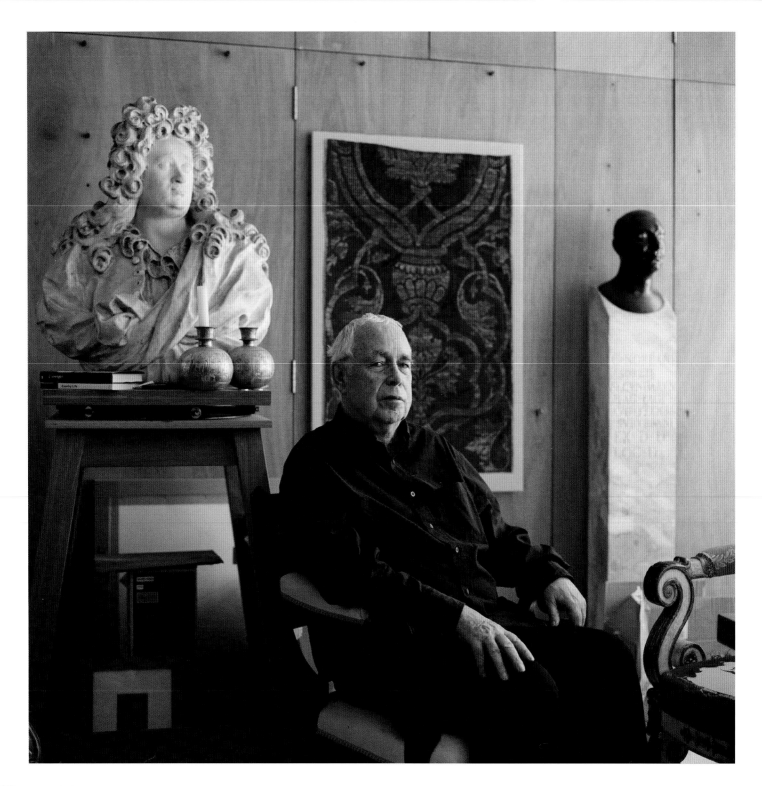

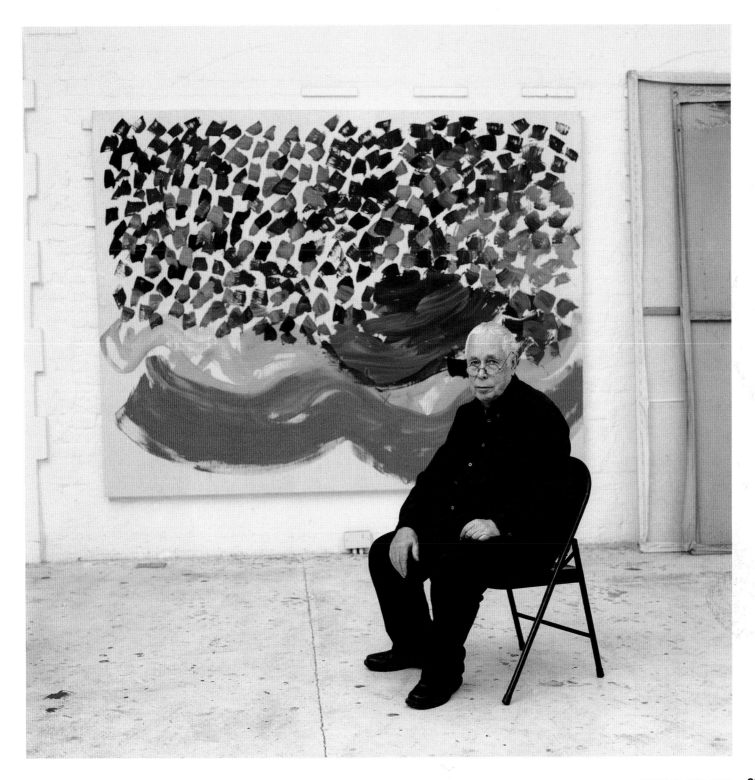

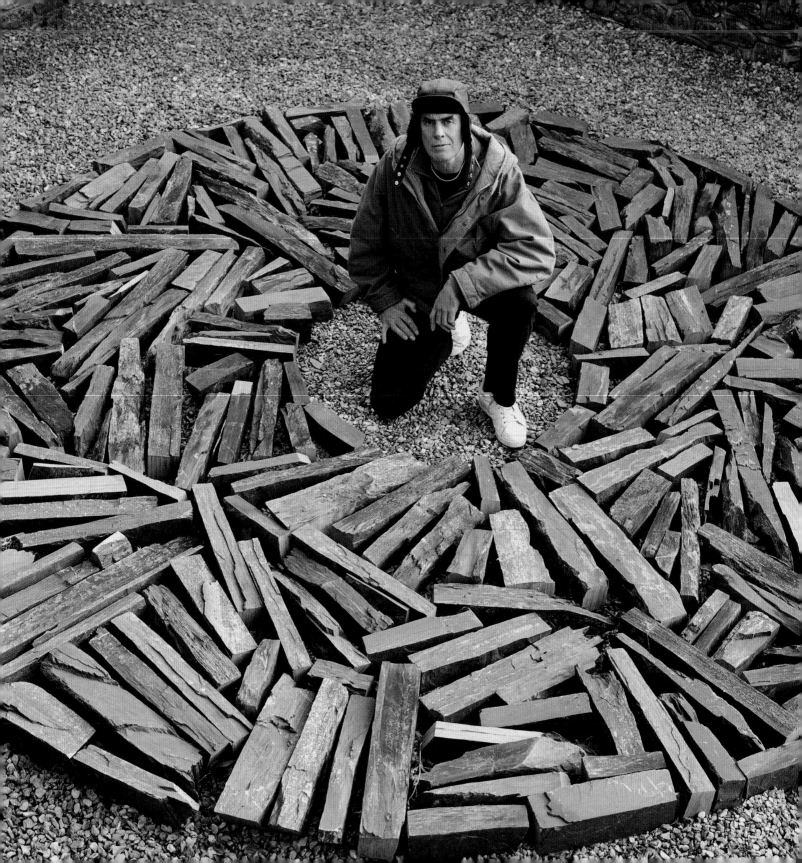

Long has taken Paul Klee's famous statement that his drawing consisted of taking a line for a walk and turned it round; Long's first typical work involved taking a walk along a line, over grass. He calls it experiencing landscape in real space, so clearly, although his form of art has closer analogies with Neolithic art than with Klee, the concept of real space in art is very modern, like real time in a film or staged drama. Real time isn't all: there are the real problems as well. A walk in the country can only be art if it is to be demonstrated to

RICHARD LONG

He carries his studio in his rucksack, through the remote regions of the world, deserts and icecaps, mountains and great valleys, walking to make an art sunk deep in our culture that might still impinge a little on our consumer culture.

an audience; and that can only be done by making a photographic record, or mapping it, or keeping a journal, all of which come into Long's activities. When he builds cairns of stone or lays out huge, simple geometric shapes with indigenous rock, he cannot simply choose a spot on the Salisbury plain like the builders of Stonehenge. He has to take photographs of what were obviously deeply impressive works, but which become less so hanging on a wall, cut down to size, the wrong size. If he wants the actual physical manifestation, he can choose to leave it buried in the wilderness and hope that it will, like caveman art, be rediscovered in some unimaginable future; or he produces it in an allocated space, probably urban, probably a gallery, and then it becomes something else, something tamed, neutered even, by urban reality. And yet, 40 years after that first walk leaving a long vanished track in the grass (*A Line Made By Walking*), Long keeps building, and recording, and walking the walk, and dreaming, I suppose, the dream of reminding us of the primeval slime from which we came.

The plot so far: September 1967, two young art students, George Passmore and Gilbert Proesch, meet at St. Martin's School of Art. It was love at first sight, they say later, though given their po-faced attitude to truth that might mean anything or nothing. They decide to turn their joint selves into a living sculpture, and have remained a living sculpture ever since, night and day, work and play (though play is an aspect of work). The first manifestation is as *Singing Sculpture*, for which they don the immaculate suits that would become a trademark, colour their heads with gold paint, and sing the Flanagan and Allen music hall song *Underneath the Arches* continuously for hours at a time.

GILBERT AND GEORGE

The dirty words, the abuse, the crude insults, the racism, is the stuff of life they encounter every day, hurled at them or sprayed on walls, and transfer deadpan to their art.

Later they create a drunk sculpture, in which they embark on a drinking binge on Gordon's gin and subside in the pools of booze and broken glass; the photographs of this little escapade are bound handsomely in a limited edition hardback volume with the title, *Dark Shadow*, embossed in gold and a commentary in dodgy stream-of-consciousness prose (as well it might be in the circumstances) and dodgier typography. Their reputation is made, they buy the living sculpture a handsome former silkweavers' Georgian house in Spitalfields to live in, and in late middle age they, and it, are awarded a big retrospective at Tate Modern.

Actually, rather than the Cockney duo Flanagan and Allen, Gilbert and George were always closer to the Western Brothers, the elegantly tailored supposedly upper crust vaudeville act, or maybe even, given the suits, to Swan and Edgar. G&G wear their suits and ties, though possibly not the gold paint, from morning to night, even when they are in their workshop; unless they are being photographed naked for one of their works. But whereas the Western Brothers wowed the nation, G&G wow very few people, least of all Ann Widdecombe, who from her uniquely privileged insight as an MP warned them of the wrath of God to come after they exhibited their highly blasphemous art works *Sonofagod: Was Jesus Heterosexual?* This was a question which they probably had no reason to ask but saw no reason why they shouldn't. "Christians are abusive to humans – to women, to queers. They threaten us with hell," George told the press. "That's offensive, not us."

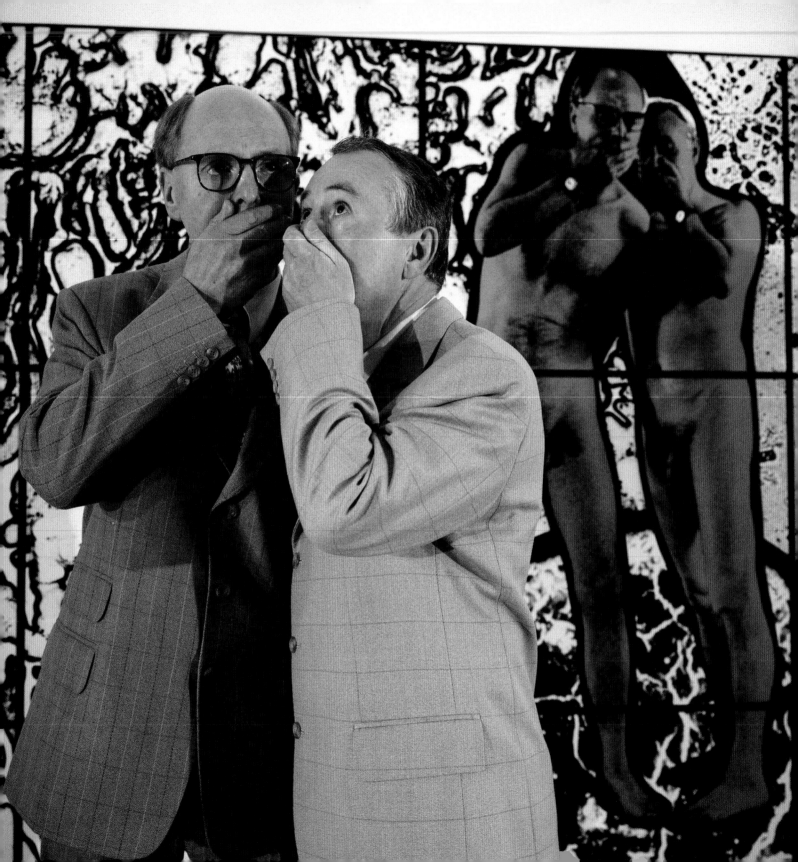

They have been accused of many other things as well blasphemy, including being fascist, though in fact they live happily in a multicultural community close to Muslim Brick Lane and dispense the tolerance that often isn't reciprocated. But they go forth from Fournier Street every morning and multiply: that is, they collect the material for their work. The dirty words, the abuse, the crude insults, the racism, is the stuff of life they encounter every day, hurled at them or sprayed on to walls, and transfer neatly lettered, deadpan, to their art. Where the publisher's name should have been on *Dark Shadow*, Gilbert and George inserted Art For All, a gentle irony that would have been nothing but the truth if it had read Art From All.

G&G wander through their own art on huge surfaces once drawn (charcoal on paper sculptures), now usually photopieces typically divided into a grid of square panels with conflicting or confirmatory images; some of the earliest include *Cunt Scum*, where the title comes from photographed graffiti and other panels might be new photographs: a wary policeman, a crowd of workers, a skyline of office towers, a wet, empty, badly kept street. It's one of a series called *The Dirty Words Pictures* put together in the late 1970s when the National Front was stirring up trouble in mixed communities. Since then the photopieces have become harshly and garishly iconic, much less laid back, seemingly much more fearful of the slide into intolerance.

"... we're not invited to a lot of things now because people expect a disaster to happen"

David Mach is the visiting professor of inspiration and discovery at Dundee University, a position created for him. He's started off with a photo montage showing the sculpture of a young naked woman on campus, presumably about fifty feet tall; she is very much a woman of today, a bit like the nude opposite made with coat hangers (hence the nimbus): the Dundee nude too has a bob hairdo and casual attitude, one hand on her hip and the other forearm leaning on the flat roof of the building beside her as though she is ordering a drink at the union bar. The university website is discreetly silent about whether this is a project that will go forward.

DAVID MACH

"I have been working with Dundee University as professor of inspiration and discovery. It's a newly created position and a helluva title and one that I find hugely beneficial to me."

Maybe it's inspirational, imaginative, provocative, inventive and funny surely, all of which tend to be characteristic of Mach's work, certainly of *Polaris*, the submarine made of about six thousand rubber tyres which he installed outside the Hayward Gallery in 1983. This provoked a member of the public to douse it with petrol and set it ablaze; we shall never know whether it was a protest against modern art or against militarism because the vandal inadvertently set himself on fire terminally as well. Mach himself deals in conflagration, making portrait sculptures out of unlit matches then sometimes burning the match ends to achieve a different colour effect. Collage, montage, tyres, discarded vehicle parts — Mach uses anything going. If you had to make a choice, then maybe it would be the two railway sculptures. First, there's *Train off the A66 in Darlington*, though it's only the engine trailing a plume of smoke. But this is smoke without fire, because the 80-yard-long engine and plume of smoke is constructed of 185,000 bricks going nowhere fast. It's the Mallard, a loco of 1937, because although the borough commissioned it in 1996 to commemorate the town as the home of railways, George Stephenson's Loco No.1 of 1825 (the real one) is already there in the railway museum. Lateral thinking from Mach: the Mallard lasted until the Sixties and probably hauled more trains through Darlington than any other engine. And the A66 is the Stockton road. Secondly, at Euston Station, there are two giant sumo wrestlers holding a truck-sized freight container off the ground, enough to give anyone looking at it a hernia.

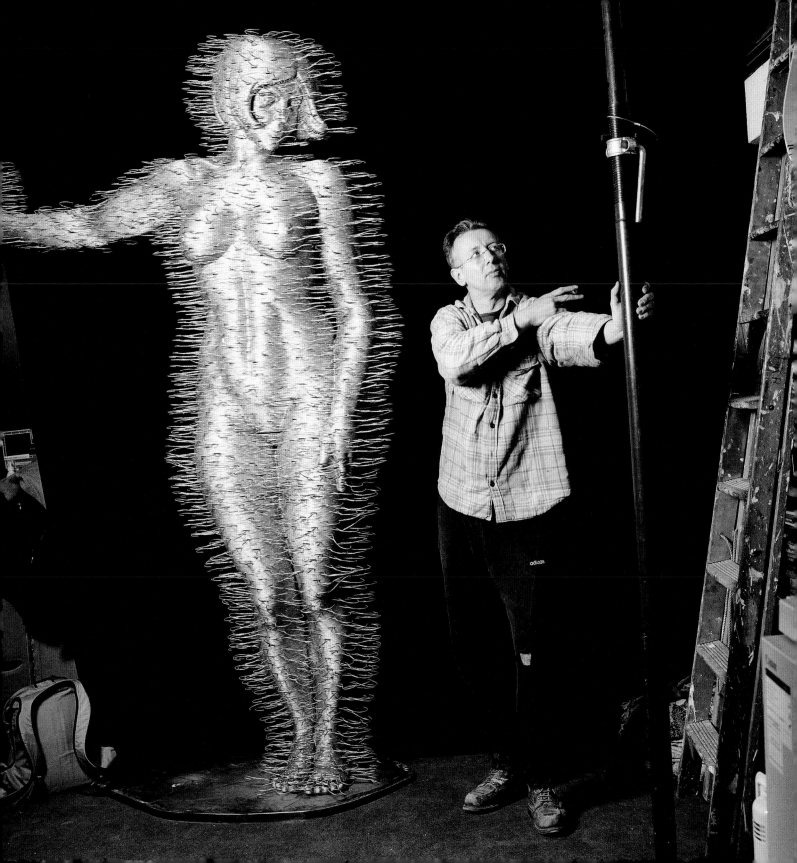

The Royal Academy hung its Auerbach retrospective in 2001 in galleries adjoining a show of paintings of women by Rembrandt. The old master seemed a dangerous companion for Auerbach, but he survived it undiminished. Rembrandt was a master in ways which have been long lost, but in the central issues of commitment, intensity and focus Auerbach lacks nothing. He paints building sites as though he was bricklaying and for portraits and nudes he trowels on paint in layer after layer. Then he scrapes it off and starts again. And again. With drawings too he works on layered sheets of paper and the charcoal scratches through the top sheet to the hidden surfaces, relentlessly seeking the reality behind appearance.

FRANK AUERBACH

Home is where the studio is: a bed on a mezzanine floor above the studio space in Camden Town so that he can slip out of bed and start work within a minute or two.

He was born in Berlin two years before Hitler came to power. In 1939 his parents sent him to England but remained in Germany waiting for Hitler to stop showboating on the Jewish issue. They died in the camps. Well-wishers sent young Frank to school in Kent; he emerged feeling secure in his adopted country but without much formal education. He messed about a little in the theatre then had the luck to begin art lessons at Borough Polytechnic under the artist David Bomberg, now legendary, but at that time a legend only to his pupils. Even when he moved on to St. Martin's and then the Royal College of Art Auerbach continued classes with Bomberg, who encouraged speed and risk taking, aiming at what he called the primary image.

He has remained ever since, painting in his Mornington Crescent studio and never further abroad than the South Bank or Bethnal Green. His models, Estella West (E.W.W., as she is always identified in the portrait titles), his wife Julia Mills (J.Y.M.), Catherine Lampert, his son Jake, his friend David Landau, have all modelled at a given time each week for years, even decades, while Auerbach lays down a tempest of paint on the surface of the canvases.

In 2001 Jake and Hannah Rothschild made a film about him. At the end the camera discovers Auerbach studying Constable's *Hay Wain* in the National Gallery. Do you measure yourself against these masters? Rothschild asked. Once, yes, he said, now he sought their help; of every thousand hard-working artists 999 would immediately be washed away in the stream of history. Others might last two, three, four hundred years. "It isn't really a success game," he concluded.

Damien Hirst's shark fetched up at the Metropolitan Museum, New York, in late 2007 for a three year spell. The shark, as everyone calls it in unsurprising preference to Hirst's own title, *The Physical Impossibility of Death in the Mind of Someone Living*, met a relatively cool reception; relative, that is, to its first appearance in London, where it had been commissioned by the collector and trend setter Charles Saatchi from the head of the clan of Young British Artists, and delivered in 1991, in good time for the following year's YBA show in the Saatchi Gallery. After that the cadaver of the fourteen foot tiger shark swiftly rotted, despite the 4,360 gallons of formaldehyde it floated in, so what the Met put on show

DAMIEN HIRST

From the shark to the £50 million diamond encrusted skull, the enfant terrible of Young British Artists has continued to hold the art world in thrall on both sides of the Atlantic.

was a replacement, smaller and much heralded, which might account for the coolness of its reception in this shock-proof town. But then, the Tate's *Fountain*, a pissoir so called by Marcel Duchamp, is a replacement. And how much of Leonardo pigment remains in the *Last Supper*, to pass from the sublime to the ridiculous? Precious little.

Precious, rung up on the till, is the precise word. Saatchi had guaranteed to buy anything Hirst produced. When Hirst and Saatchi fell out a little later, it is said Hirst paid the collector around £8 million for a dozen works he had originally sold to him for nearer £10,000. Today, dealers only start counting in millions. Hirst has called his spot paintings shite, and I'm not arguing. But this is the art world, and when an investment fund buys Hirst's diamond studded skull for £50 million, then the art comes second. Hirst now lives in Mexico for three months of the year and the skull is indeed based on a jewel encrusted Aztec skull, but that's in the British Museum, and its authenticity too has been questioned.

Does any of this matter? Of course. The shark, after all, was a brilliant stroke. Hirst became an artist when he was hooked as a youngster by the critic David Sylvester's interviews with Francis Bacon. Bacon's screaming figures were based partly on the screaming nurse in Eisenstein's revolutionary movie *Battleship Potemkin*, partly on Velazquez's portrait of the Doria-Pamphilj pope; so the gaping jaws of Hirst's shark have an interesting pedigree and close the circle, returning the jaws of death to the pop culture of the *Jaws* movies. After that it's been the primrose path all the way; everything has become too easy, not just clowning outrageously in interviews, but in his work. Pity, really.

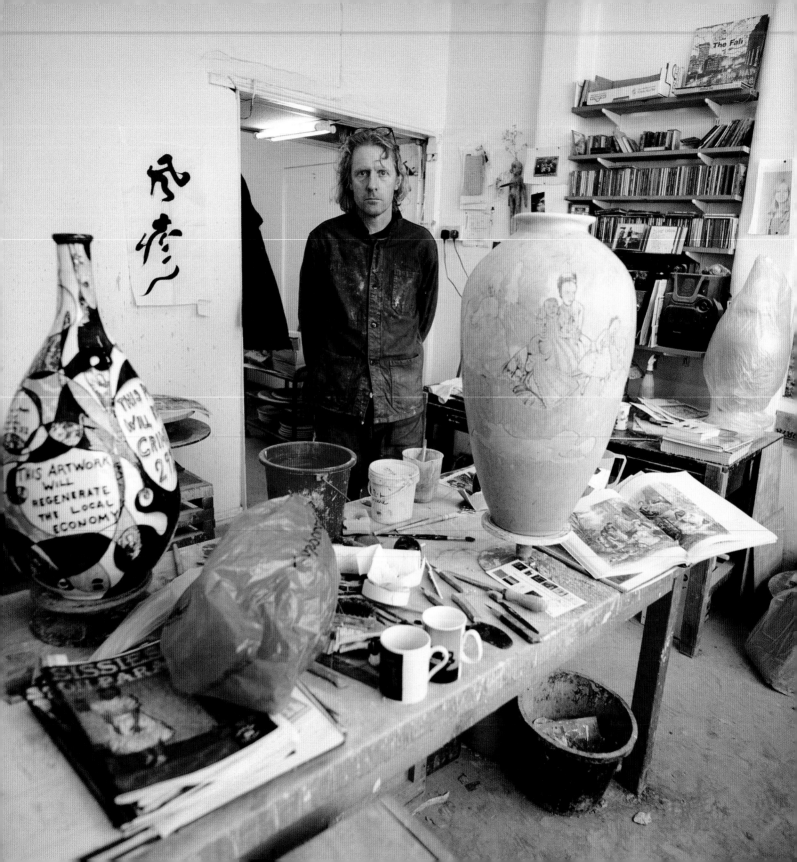

It caused a stir when Claire went up in her party dress to collect the Turner Prize that Grayson Perry won in 2003. Claire stepped up in a pretty party frock with Mary Jane shoes, quite a lot younger than Perry's daughter, who was ten at the time; but then Claire is Perry's creation too, his alter ego. Perry has known from the age of thirteen that he was a transvestite. He puts it down to his upbringing: in Carry On fashion the milkman impregnated his mother and progressed to being a sour stepfather who scared little Grayson into creeping up to his room and creating a fantasy life for himself. It's the fantasy life that is at the root of his art, and his art is what caused the secondary stir, because it is conventional pottery, and has what Perry has called taxi driver credibility, which means that no one is going to look at it and say "my three year old could do better". But on the glazed surfaces of the ceramics are graphic explorations of the rottenness of society, the cruelty, the alienation, the loss of innocence.

GRAYSON PERRY

The best-known title, if not pot, gives the general idea: We've Found the Body of Your Child. The subjects are dissolute, desperate, and full of shame for the way society treats the vulnerable.

The public liked Perry's Turner presentation, but not all the critics did, pointing out that the artist was neither a particularly good potter nor an outstanding graphic artist. But once critics start making those points, the cat is out of the post-modernist bag. Tracey Emin a first rate needlewoman? Was Pollock much more than adequate with a brush in his hand? Why did Clement Greenberg suggest that it wasn't the execution that mattered, it was the concept? With Perry, three things go together: the pots, the graphic treatment, and the intense engagement with his subject. The point of the pots is that they are not bad, but they are not art pottery; they are too conventionally bulbous bodied and narrow necked to be sold in, say, Habitat or John Lewis; but when you look at them closely, the disjunction of a vase's appearance with the beautifully glazed illustration is total. The best-known title, if not pot, gives the general idea: *We've Found the Body of Your Child*. The subjects are dissolute, desperate, and full of shame for the way society treats the vulnerable. This doesn't make it great art, but its engagement accounts for its interest. Oddly enough, for his degree Perry mostly studied film. Now he's moving into embroidery. Watch out Tracey.

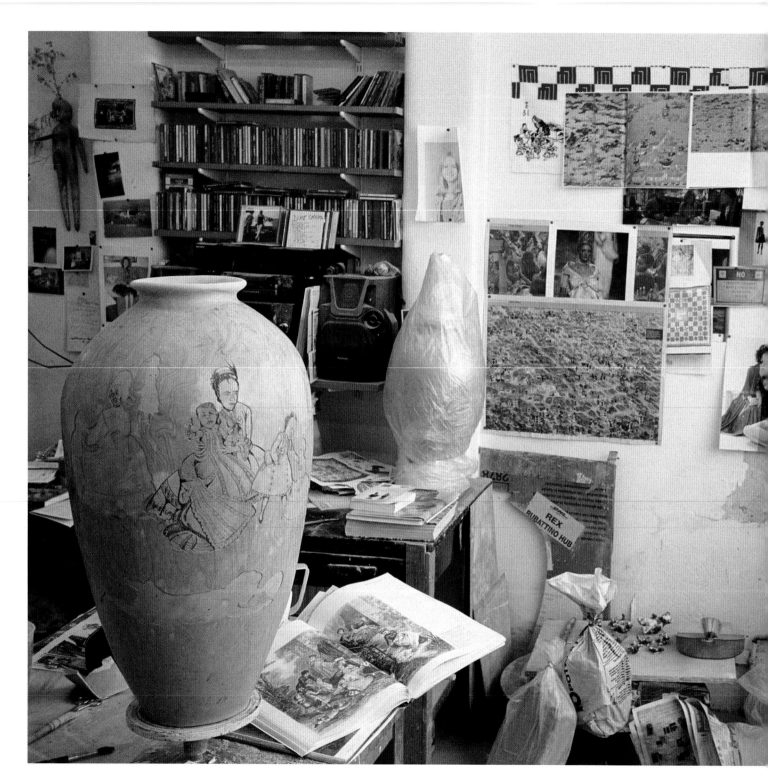

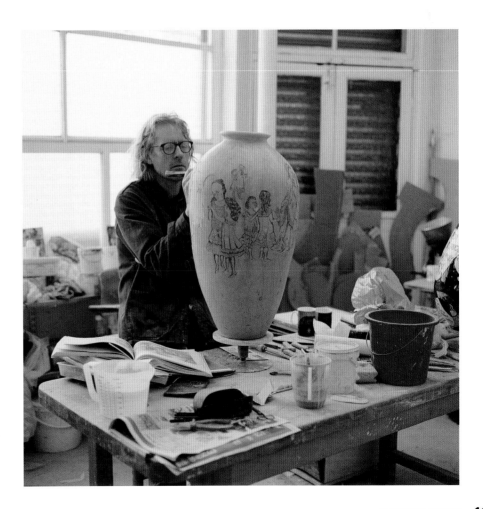

"I can be outrageous because the vice squad is never going to raid a pottery exhibition"

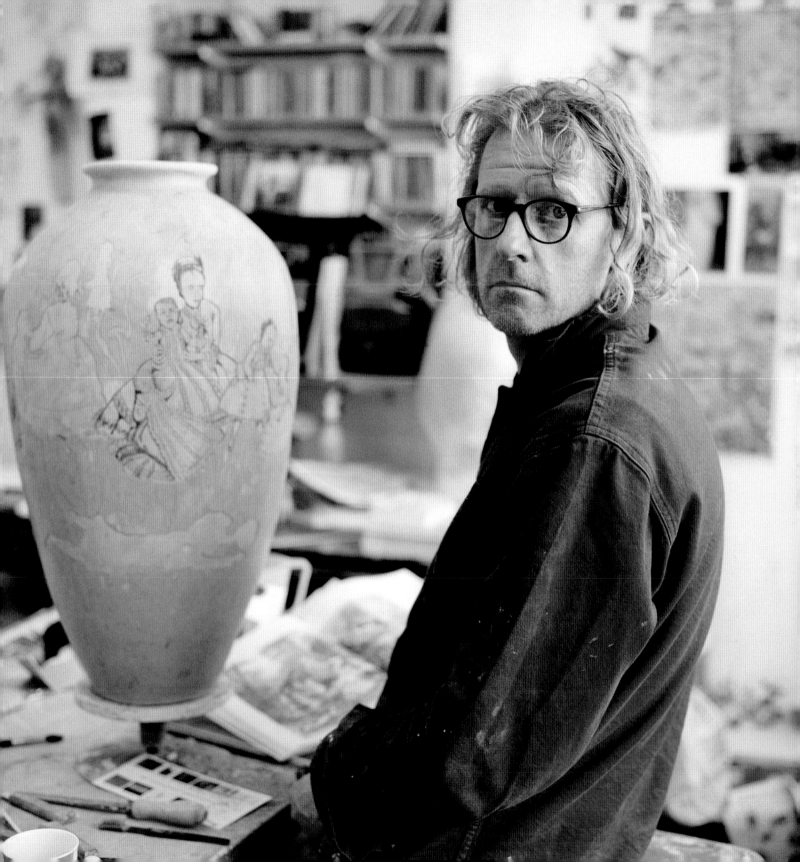

ABOUT THE AUTHORS

Michael McNay

EAMONN McCABE is pursuing a highly successful career as a portrait photographer after several years as picture editor of *The Guardian* from 1988, the year he became a fellow of the National Museum in Bradford. As a young man he broke into national newspapers as a sports photographer and went on to win Sports Photographer of the Year an unprecedented four times and to be nominated as Photographer of the Year in 1985. He has had many shows including at the Photographers' Gallery, London, and the Walker Art Gallery, Liverpool; and television and radio have made him a sought after public speaker. He has been awarded an honorary doctorate of letters by the University of East Anglia and lectures regularly around the country on the role of the image in the media.

MICHAEL McNAY is a freelance writer and author of a book on Patrick Heron (Tate, 2002). A 37-year career on *The Guardian*, where from 1988 he worked closely with McCabe, included spells as arts editor, design editor, and front page editor.

Eamonn McCabe photographed by Beth Elliott, 2007

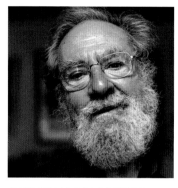

PETER BLAKE

Born 1932

Born in Dartford and educated at Gravesend Technical College and Gravesend School of Art, Blake's breakthrough was to win a place at the Royal College of Art. Early in his student career he began drawing on press photos, posters and fanzines for subject matter, heavily centred on his main enthusiasms, boxing, wrestling, and rock-'n'-roll, and in 1956 he won a Leverhulme award to travel and study popular art. At the RCA he was an older contemporary of David Hockney, Allen Jones, Derek Boshier, and the sadly short-lived Pauline Boty; with some of them Blake achieved his first fame in Ken Russell's film *Pop Goes the Easel* (1961), made for the BBC Monitor arts series. Blake's greatest popularity was achieved with the cover for the Beatles' *Sergeant Pepper* album, on which he collaborated with his wife, Jann Haworth: the two of them joined a few other artists in founding the Brotherhood of Ruralists. They divorced in 1981 and in the same year he became a Royal Academician. Throughout his career he has drawn no distinction between his commercial and fine art activities. He has work in major public collections and has exhibited all over the world.

See page 8

MAGGI HAMBLING

Born 1945

Hambling grew up in Suffolk and although she studied at Camberwell and the Slade School of Art, her most enduring influence came from the artist Lett Haines who ran the East Anglian School of Painting and Drawing situated in Hadleigh where she grew up. Cedric Morris was principal and Lucian Freud had been a student in previous years. Hambling maintains studios in London and Suffolk. She was the first Artist in Residence at the National Gallery in 1980 and jointly won the Jerwood Painting Prize with Patrick Caulfield in 1995. Her public collections include the British Museum, National Portrait Gallery and Tate collection. Her most controversial works have proved to be her memorial to Oscar Wilde, behind St. Martin in the Fields, London (1998) and *Scallop* to celebrate Benjamin Britten, on Aldeburgh beach in Suffolk (2003). *Maggi and Henrietta – Drawings of Henrietta Moraes by Maggi Hambling* was published by Bloomsbury in 2001 and the monograph: *Maggi Hambling: The Works and Conversations with Andrew Lambirth* by Unicorn Press in 2006.

See page 12

SANDRA BLOW

Born 1925, died 2006

From 1941 to 1946 she studied at St. Martin's School of Art and the Royal Academy Schools. In 1947–8 she was in Rome where she studied at the Academy of Fine Arts and became the lover and de facto pupil of the abstract artist Alberto Burri, from whom she learned a philosophy and practice of art that underpinned her entire career. After Rome, she spent some months travelling in France and Spain. Her first London exhibition was at Gimpel Fils in 1951. In 1957 she went to visit Patrick and Delia Heron and stayed in Cornwall for a year. Subsequently she spent many years working and exhibiting in London, including a retrospective at the Sackler Rooms of the Royal Academy. She was a joint winner of the International Guggenheim Award (New York, 1960) and second prize winner at the John Moores Liverpool Exhibition (1961). She taught at the Royal College of Art where she was elected an honorary fellow in 1973. She returned to St. Ives in the early 1990s and had a retrospective show at Tate St. Ives in 2001–2

See page 16

ANTHONY EYTON

Born 1923

Studied fine art at Reading University 1941; army service 1942-7; further study at Camberwell School of Art 1947-50. In 1951 he won an Abbey Major Scholarship and went to work in Italy. Among many London exhibitions he has regularly shown in solo shows at Browse & Darby. He has travelled to India, Africa, and Israel and Sudan and in 1982 he was commissioned by the Artistic Records Committee to paint the Gurkha regiment in Hong Kong; these paintings went on exhibition at the Imperial War Museum. Among many other commissions, he painted the turbine hall at Bankside Power Station before its conversion into Tate Modern; two of these works are now in the Tate collection. He is currently artist in residence at the Eden Project in Cornwall. He was elected a Royal Academician in 1986. In 1972 he was John Moores prizewinner in Liverpool.

See page 20

MARY FEDDEN

Born 1915

Left the up-market girls school Badminton with relief aged 16; studied at Slade School of Art 1932-6. There met Julian Trevelyan and fell in love but he was already married and she had to wait until 1949 when Trevelyan's wife walked out and suggested he take Fedden on holiday. They married in 1954. He taught her print making and introduced her to the spatial discoveries of Cubism. They worked together in their Chiswick home and studio until his death in 1988, and she has been there ever since. Her childhood home was Bristol and she has shown at the Arnolfini Gallery there and from 1984-8 was president of the Royal West of England Academy, which mounted a retrospective of her life's work in 1996. In London she has shown at the Redfern, New Grafton, Hamet, and Beaux Arts (1993 incarnation, not 1950s). She became a Royal Academician in 1992.

See page 24

TRACEY EMIN

Born 1963

Emin's father is a Turkish Cypriot; she was born in London but grew up in Margate. Trained at Maidstone School of Art and the Royal College of Art. Lives and works in London. She began exhibiting in 1993 when she and Sarah Lucas opened a shop (The Shop) in Bethnal Green, and held her first solo show at the White Cube gallery the same year; with typical bravado, it was called *My Major Retrospective*. She exhibited with the shortlisted artists for the 1999 Turner Prize ("should have won," her website says; Steve McQueen, who did, might have other ideas); among her work was *My Bed*, later bought by Charles Saatchi and included in *Sensation*, the notorious Young British Artists (YBA) show at Burlington House drawn from the Saatchi collection. Her work is confessional, including such items as an embroidered tent called *Everyone I've Ever Slept With* (subtler than the title suggests) and exhibitions such as *My Cunt is Wet With Fear* and *You Forgot to Kiss My Soul*. Her subjects include rape, abortion, and promiscuity, all drawn from her own experience.

See page 28

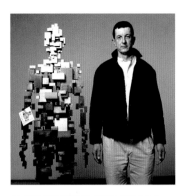

ANTONY GORMLEY

Born 1950

Went from Ampleforth College to Trinity College, Cambridge, where he read archaeology, anthropology, and art history (1968-71); in 1971-4 he visited India and Sri Lanka and studied Buddhism. Back in London he completed a Slade postgraduate course. The influence of his Buddhist studies shows in the quietism of his work. Was given his first show in 1981 at the Whitechapel Gallery with Tony Cragg by its director at the time, Nicholas Serota, a contemporary of the artist at Trinity. Won Turner Prize in 1994 with *Field for the British Isles*: 40,000 figures between three inches and ten inches tall in rich-hued terracotta. This was one of a series, including *Asian Field* (2003) of 190,000 figures made by 350 local helpers under the direction of Gormley in south China. Best known in Britain for Angel of the North, a 66 ft tall steel figure with a wingspan of 178 ft, situated beside the A1 approach to Gateshead. His installation in 2005 of 100 life-size cast iron figures on Crosby Beach, Merseyside, where some were almost submerged as the tide came in, aroused huge interest and the usual media controversy attending modern publicly sited sculpture.

See page 30

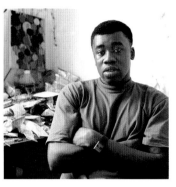

CHRIS OFILI

Born 1968

British artist from Manchester with Nigerian parents; works on the theme of black identity. Studied at Chelsea School of Art (1988-91) and Royal College of Art (1991-3), and in 1992 won a travelling scholarship to Zimbabwe, an experience that inspired him to work without deference to Western norms of good taste in colour, shape, or even materials: he uses elephant dung, most notoriously in a painting called *The Holy Virgin Mary* which aroused the anger of the Mayor Rudy Giuliani of New York. Ofili's Mary was an African goddess; he also created a character based on strip comic heroes, but more vulnerable and more dubious in character, Captain Shit. Ofili was taken up early in his career by Charles Saatchi and was one of the Young British Artists included in *Sensation*, the Saatchi collection show at the Royal Academy in 1997. In 1998 he won the Turner Prize, but a still greater prize came in 2002 when Tate bought 13 Ofili paintings and displayed them in a setting called *The Upper Room* specially designed by the architect David Adjaye; Ofili is the only artist apart from Mark Rothko to have received this treatment.

See page 36

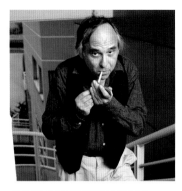 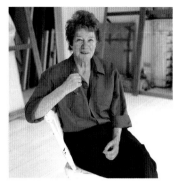 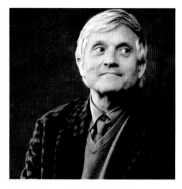 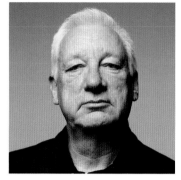

ART SPIEGELMAN

Born 1948

Spiegelman's parents were Polish Jews who survived Auschwitz, an event which has coloured his work ever since. He was born in Stockholm but when he was still a boy the family moved to the United States, where he studied at Harpur College, New York (1965-8). In 1968 he suffered two nervous breakdowns and when he was released from hospital his mother killed herself. Influenced by the underground comic strips of the 1960s began to produce his own strips aimed at an adult audience. The first *Maus* book appeared in 1970 and the second in 1991 (they have since been published as a single volume); in 1992 he won a special Pulitzer Prize for the *Maus* saga and the artwork was exhibited at MoMA, New York. His wife, Françoise Mouly, as art editor of *The New Yorker*, commissioned the front page from him for the special issue following the al-Qaeda attack on the World Trade Centre: it showed two spectral towers, black on black. He followed this by producing *In the Shadow of No Towers*, which commemorated the event and celebrated more than a century of American comic strips which encapsulated for him the rich variety of US culture.

See page 40

BRIDGET RILEY

Born 1931

The most eminent British practitioner of what became known as Op Art, Riley's first New York show was a sellout before the exhibition opened, which brought her little but trouble. Firstly, the rag trade ripped off her paintings; secondly she discovered there was no US copyright protection (something she fought hard and successfully to rectify); thirdly, critics assumed that her paintings were "merely" decorative. Over a long career moving from black and white into the full range of colour Riley has won acceptance as an artist. Educated at Cheltenham Ladies College, where a relaxed regime allowed her to give her attention to art instead of academic studies, Goldsmith's, and the Royal College of Art, she maintains that childhood experiences of the Cornish land and seascape formed her sensibility. One of her initial influences was Seurat, and among other writings and interviews collected in her book *The Eye's Mind*, she has analysed her work with great perception.

See page 42

DAVID HOCKNEY

Born 1937

Hockney himself must be fed up of this story, but no one else is. When he was studying at the Royal College of Art his teachers didn't know whether to pass him or fail him. In the end, the head of college, Robin Darwin, insisted that he should receive the gold medal; which Hockney duly accepted in a ceremony for which he dressed in a gold lamé jacket. The lad from Bradford has never looked back, though recently he has been spending more time in England, complaining in letters to the editor about the relentless campaign against smoking, visiting his sister near Bridlington, and painting the Yorkshire dales as they have never before been seen. His first big success, while still at the RCA, was his series of etchings *The Rake's Progress*, based on Hogarth and rather more on his own experiences of a first visit to New York. He draws brilliantly, has been a popular success as a printmaker, and created several great designs for opera, including the Glyndebourne production of Stravinsky's *Rake's Progress* for which Hockney turned to Hogarth's engravings more closely. A converted wool mill in Saltire has a collection covering Hockney's career from his school days.

See page 46

MICHAEL CRAIG-MARTIN

Born 1941

As both teacher and in his practice Craig-Martin has been highly influential with the younger generation of artists, specifically the YBAs, though he was born in Dublin and his parents took him to the United States when he was four. He trained at Yale under Alex Katz and the hard edge abstractionist Al Held and didn't come to Britain until 1966 when, after a few years teaching at Bath Academy of Art he moved to Goldsmith's and became senior tutor. His work draws on both Dada and Pop with an intellectual underpinning of conceptualism and is typically an exhilarating synthesis of everyday consumer objects in brilliant colour, frequently and exhilaratingly an actual building surface, sometimes the whole surface of a wall, inside or out.

See page 50

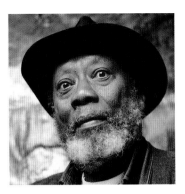

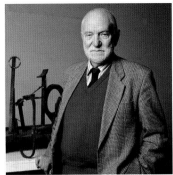

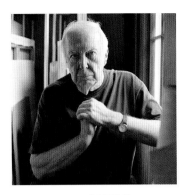

FRANK BOWLING

Born 1936

Bowling arrived in London as a teenager from his birthplace, Guyana, and is often referred to as Britain's most distinguished black artist, a description he resists on the ground that he is an artist in the western tradition even though it remains possible that his sense of colour may have a residual source in childhood impressions. He won a scholarship and trained at the Royal College of Art in 1959-62, winning the silver medal on graduation in the year that Hockney took gold. He lived for a while from 1966 in New York, where the critic and champion of the abstract expressionists, Clement Goldberg, persuaded him that his future career lay in abstraction. He has works in collections like the Museum of Modern Art and the Metropolitan Museum in New York and the Tate. He was elected a Royal Academician in 2005 and became, it has to be said, the first black artist to be honoured in this way.

See page 54

ANTHONY CARO

Born 1924

Caro was born in New Malden, Surrey, and educated at Charterhouse and Christ's College, Cambridge, where he took a degree in engineering. Later he presented Christ's with a sculpture based on Rubens's Deposition which now stands in the college chapel. He worked for Henry Moore at Much Hadham in the 1950s and was initially influenced by him but broke through into his mature style after visiting the US and meeting David Smith. He bolted together I-beams, steel rods and plates and strong steel mesh to construct the abstract polychrome sculptures which brought him huge international success and great influence on a highly talented group of sculpture students at St. Martin's School of Art, including Philip King, David Annesley, Tim Scott, and William Tucker, who showed together in the New Generation show of 1965 at the Whitechapel Gallery, where Bryan Robertson had also given Caro himself his first big retrospective a couple of years earlier.

See page 60

JASPER JOHNS

Born 1930

The son of a farmer in South Carolina, Johns, like many American artists, grew up without ever seeing a work of art or knowing what it meant to be an artist (in his case, home was South Carolina). At 18 in New York he saw a Picasso and hated it, but still decided he would be an artist. His success arrived with spectacular suddenness when he painted *Flag 1954-5*, the first of a series turning the, until then, sacrosanct stars and stripes into a work of art. New York was hungry for a popular successor to abstract expressionism, and Johns was it. He moved on into sculptures in bronze of beer cans, flashlights and in one case a studio object, a can holding painter's brushes. Despite its obvious similarity to pop the roots of this work were in dada (which he had to read up after a critic remarked of his first flag that it was a dada image). A loner, Johns works most of the time in a Connecticut studio two hours from New York. Regardless of the comparative lack of acclaim for his later abstractions he has become one of the richest artists in the world.

See page 62

JEFF KOONS

Born 1955

Possibly his most famous work is *Puppy*, a monster dog made of living, growing flowers on a steel frame which sits outside the Guggenheim Museum in Bilbao. His work divides critics into two camps, those who think he's marvellous, and those, like Robert Hughes, who regard him as a "starry eyed opportunist par excellence". Born in Pennsylvania, Koons trained in Chicago and at the Maryland Institute. Among his singular achievements have been to marry the Italian porn star Cicciolina (née Anna Ilona Staller) and photograph their sexual activities together; to commission a pop song about himself; and to create a gold plated statue of Michael Jackson which sold at Sotheby's for $5.6 million. In 2005 the American Academy of Arts and Sciences elected him a fellow.

See page 66

ELLSWORTH KELLY

Born 1923

After military service during the war Kelly went on the GI Bill of Rights to study in Paris where he learned about art from the Romanesque to Arp, Brancusi, and Alexander Calder, all of whom he met. He returned home to New York in 1954 and painstakingly developed an approach of pure abstraction, at the same time building a reputation that reached a peak in 1973 when MoMA gave him a retrospective. He adapted his forms from painting to aluminium and steel sculpture and his commissions include a mural for the UNESCO HQ in Paris and sculpture in 1978 for the city of Barcelona, then in the process of renewing itself. Another retrospective, organised by the Guggenheim, New York, in 1996, also travelled to the Tate.

See page 68

PAULA REGO

Born 1935

Rego grew up in Lisbon, her birthplace, during the dictatorship of President Salazar. She came to England to study at the Slade School of Art. There she met the brilliant young English artist Victor Willing and, when he obtained a divorce, married him. She gave up art to look after him during the long illness that led to his death in 1988. She resumed painting, developing the powerful figurative style for which she is best known, unblinkingly portraying the brutality of ordinary lives and particularly as it is inflicted on women. She has been awarded honorary doctorates by East Anglia University, St. Andrews, and Oxford among several others. In 1983 she was appointed visiting lecturer at the Slade and in 1990 she became the first associate artist at the National Gallery, where she painted the big mural in the Sainsbury wing restaurant.

See page 70

BARRY FLANAGAN

Born 1941

Studied at Birmingham College of Arts and Crafts and St. Martin's, under Anthony Caro; he taught there after he graduated in 1966. Represented Britain in the Venice Biennale of 1982 and in 1993-4 had a retrospective exhibition that was shown in Madrid and Nantes. His athletic bronze hares have lined O'Connell Street in Dublin, Park Avenue, New York, and the Champs-Elysées. In 2002 another major show of his work was seen in Recklinghausen, Germany, and Nice. The hugely popular hares seem to have been around for a very long time but in fact he made the first in 1980; before that he had worked with sacks filled with sand or plaster and had moved on to make refined abstract sculptures in various kinds of stone. In 1987 he moved to Ibiza but now lives and works in Dublin.

See page 76

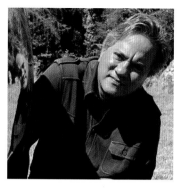

ANISH KAPOOR

Born 1954

Kapoor came to England in 1972 from India, where he had been born in Bombay and educated in the Himalayan foothills at Doon School in Dehra Dun. Studied at Hornsey College of Art and Chelsea School of Art. Has kept in touch with Indian culture with frequent visits and adopted something of the quietism of the Barnett Newman's paintings and the resonant single colours of Yves Klein. The pieces in his first exhibitions at the Lisson Gallery in London looked quite like large Indian sweetmeats saturated with colour; his colour is still powerful (for instance *Marsyas*, his project for the turbine room at Tate Modern) but his approach to form has developed in subtlety. His mature work explores mass and void, shape and colour, light and darkness. Kapoor represented Britain in the Venice Biennale in 1990 and won the Premio 2000. He has exhibited at the Kassel Documenta and contributed a large sculpture to Expo Seville. He has fulfilled commissions for large public sculptures: *Sky Mirror* in Nottingham, and a second version at the Rockefeller Centre in New York, *Cloud Gate* in Chicago, and other pieces in Ottawa, Des Moines, and around the world.

See page 80

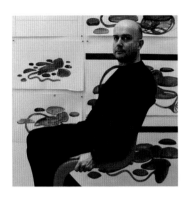

MARC QUINN

Born 1964

A Londoner by birth, Quinn studied art and art history at Robinson College, Cambridge. He graduated in 1986, worked as an assistant to Barry Flanagan, and had his first solo show at the Jay Jopling/Otis Gallery. He stayed with Jopling when the dealer opened White Cube. His early sculpture *Self*, a portrait of the artist sculpted from frozen blood drawn from his own body, brought him success in a sensation-sated art world, eventually selling for £1.5 million to a US collector. Saatchi bought his work and Quinn showed with other Saatchi artists in the 1997 Royal Academy exhibition, *Sensation*. He is best known for his sculptures of handicapped people, such as Alison Lapper, a piece which until April 2007 dominated Trafalgar Square from its plinth with its snowy whiteness. These sculptures were said to be intended to challenge the tradition of ancient Greek and Roman sculpture though they hardly resembled them. He has had a shown at the Tates in London and Liverpool, and at the 2003 Venice Biennale.

See page 82

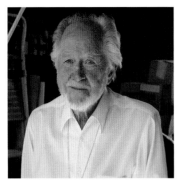

RONALD SEARLE

Born 1920

Searle was born the son of a railwayman in Cambridge, where he grew up and at 14 left school to train as a solicitors' clerk. He was sacked and moved into another short lived career packing boxes for the Co-op. He enrolled for evening classes at Cambridge School of Art and during this time took a part time job drawing cartoons for the *Cambridge Daily News* (now the *Cambridge Evening News*). At the outbreak of war joined the Royal Engineers. Posted to Singapore he arrived from one direction as the Japanese army invaded from another. He spent the war years in Changi jail and working on the Burma–Siam railway, close to death on several occasions and recording the terrible hardships and deaths of his comrades. On release he developed the girl terrors at the fictional school of St. Trinian's and had a huge success which led to advertising commissions, covers for *The New Yorker*, book illustration, books of his own cartoons, and movies featuring St. Trinians. He married his editor at *Lilliput* magazine but split up and in 1961 moved to Paris, where he met and married Monica Koenig. Still productive in his eighties he now lives in the south of France.

See page 84

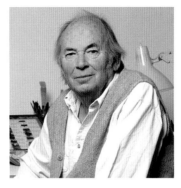

QUENTIN BLAKE

Born 1932

Studied at Chiselhurst and Sidcup grammar school, and was still at school when *Punch* published his first drawings in 1949. He read English at Downing College, Cambridge, during the period when the intellectual martinet F.R. Leavis ruled the roost. But he had been drawing all his life and after national service in the Royal Army Education Corps he went to life classes at Chelsea School of Art and quickly won a reputation as an illustrator at large, but especially for children's books, more than 300 of them by authors including Joan Aiken, Russell Hoban, and Michael Rosen as well as his closest collaborator, Roald Dahl. He taught illustration at the RCA for many years, eight of them as head of department and has won a stream of literature prizes. He initiated a illustration project in hospitals. In 2005 he was awarded the CBE.

See page 86

STUART PEARSON WRIGHT

Born 1975

Pearson Wright received the commission to paint a group portrait of the president of the British Academy with five of his living predecessors. It won him the 2001 annual BP prize for portraiture of £25,000. He was born in Northampton but grew up in Eastbourne and trained at the Slade (1995-9). He has been vocal in his attacks on the Tate for its alleged failure to support figurative art; the record of the Tate suggests otherwise, though it is true that the gallery holds nothing by Pearson Wright. His clientele includes many celebrities, from JK Rowling to Jeremy Irons, Terry Jones, Michael Palin, and Prince Philip.

See page 88

 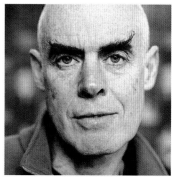

SIMON STARLING
Born 1967

A native of Epsom, Starling studied at Glasgow School of Art. His 2005 Turner Prize-winning piece, *Shedboatshed*, is typical of his approach to conceptual art, tinged by environmentalism and even, in the gibe of the pro-painting Stuckist Charles Thomson, B&Q DIY. Another typical Starling work is *Tabernas Desert Run* (2004) in which he rode a bike fuelled by hydrogen and oxygen across the Tabernas desert in Spain, admittedly only about 45 miles. The waste product of this fuel was water that Starling re-used to paint a watercolour of a cactus he had seen on his journey. And in *One Ton II* (2005) he made five platinum prints from one ton of platinum ore, to illustrate the massive discrepancy in energy consumed in producing a tiny result, and in the face of his obvious commitment it is difficult to make the obvious joke (the prints, naturally, were pictures of the South African mine from which the ore came). Starling describes his conceptualism as "the physical manifestation of a thought process", which is typically down to earth. He has studios in Glasgow and Berlin.

See page 92

SAM TAYLOR-WOOD
Born 1967

Her mediums are photography and video; her dealer, Jay Jopling, is also her husband; her subjects are often the celebrities of the London party circuit. The result is that newspaper commentators both feed on her and revile her, a hate fest which gathered force after she made a video for the National Portrait Gallery showing David Beckham asleep. Born in south London, Taylor-Wood moved with her parents to a hippy commune in Surrey. She trained at North East London Polytechnic and Goldsmiths, had jobs at the Royal Opera House and managing a night club, and twice fought off cancer. She has made films for Pet Shop Boys gigs. She was on the Turner Prize shortlist in 1997. She has two children.

See page 94

HOWARD HODGKIN
Born 1932

A Londoner, Hodgkin was born into a distinguished family: one of his relations was the Nobel Prize winning scientist Frances Hodgkin. After evacuation to the United States for the duration of the war, he trained at Camberwell and then at the Bath Academy in Corsham from 1950 to 1954. He taught at Charterhouse school and then at the Bath Academy and Chelsea School of Art. He married in 1955 and had two sons, but later came out as gay. His painting developed from a harsh, angular figurative style to the abstracts he is known for now; though he would dispute abstract, having once described his work as representational pictures of emotional situations. He has a good collection of Mughal painting and it's possible to relate his own work to their colour schemes and intimate scale. He represented Britain at the 1984 Venice Biennale, won the Turner Prize in 1985, was knighted in 1992, appointed a Companion of Honour in 2003, and had a major exhibition at Tate Britain in 2006.

See page 96

RICHARD LONG
Born 1945

Trained at the West of England College of Art in his native city, Bristol, and then at St. Martin's School of Art. He turned to land art – was, indeed, one of its initiators – on leaving St. Martin's and his "sculpture" has often been the record of his epic walks in many lands. He has many publications to his name, since land art can normally only be disseminated by photography. Since his first show in Dusseldorf in 1968 he has had solo shows all over the world. Some highlights: the Whitechapel in 1971 and 1977; MoMA, New York, 1972, Scottish Gallery of Modern Art, 1974; a retrospective at the New York Guggenheim Museum in 1986; Tate, 1990; a Hayward retrospective, 1991; Guggenheim Bilbao, 2004. In 1976 he represented Britain at the Venice Biennale and in 1989 he won the Turner Prize. Now in his 60s he continues to plough a lonely furrow.

See page 100

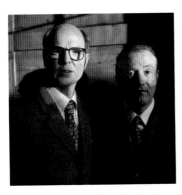

GILBERT & GEORGE

Born 1943; 1942

Gilbert Proesch was born in the southern Tyrol in Italy; George Passmore in Plymouth. Met in 1967 when they were students at St. Martin's. They decided very early to turn themselves into "living sculptures" and attracted praise and opprobrium in equal measure though their single-mindedness, which perhaps can be said of two men with one identity, has won over many of the doubters and the Tate retrospective of 2007 was a singular success. In addition to dressing as old fashioned men about town and covering themselves with paint, they have produced massive drawings and collages detailing the more striking and socially telling aspects of their daily environment in Spitalfields. They won the Turner Prize in 1986 and represented Britain at the Venice Biennale in 2005.

See page 102

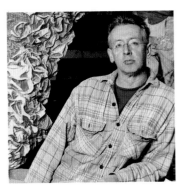

DAVID MACH

Born 1956

A Scot, Mach studied at the Duncan of Jordanston College of Art, Dundee, where he won several travelling scholarships, then at the Royal College of Art, where he won the 1982 drawing prize. In 1988 he was on the short list for the Turner Prize. He has specialised in collaged sculptures composed of readymades or found objects, from matchsticks to motor tyres. His permanent public sculptures include the famous brick-built railway engine in Darlington and the *Big Heids* sculptures along the M8 motorway between Edinburgh and Glasgow. He was elected a Royal Academician in 1988. In 1999 he became visiting professor in sculpture at Edinburgh and professor of sculpture at the Royal Academy schools in 2000. In 1988 he was elected a Royal Academician.

See page 104

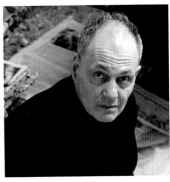

FRANK AUERBACH

Born 1931

He was eight years old when his parents sent him from Berlin to England to escape the Nazi regime. The rest of his family remained in Germany and perished in the camps. He was educated at Bunce Court at Lenham in Kent, a school founded by a German Jewish Quaker, and then took jobs acting and odd jobbing in little theatres; at one of them, the celebrated Unity Theatre, he met Estella West, who became one of his first models, referred to in titles as E.O.W. Other models included his wife and Juliet Yardley Mills (J.Y.M). But first he studied at St. Martin's School of Art, the Royal College of Art and, perhaps most importantly, two evenings a week at the Borough Road Polytechnic where David Bomberg was teaching. After college Auerbach himself taught, among other schools of art, at the Slade. In 1958 he married Julia Wolstenholme and had a son, Jake, who later, with Hannah Rothschild, made a television film of his father at work. He has always worked in the Camden Town area, Sickert territory, painting scenes of building sites, the Camden Palace Theatre, and general street scenes.

See page 108

DAMIEN HIRST

Born 1965

Hirst was born in Bristol and in time honoured fashion his father left the nest early and his mother lost control of the boy in his teens; he was twice done for shop lifting. Bad went to worse and he became an artist. He trained in London from 1987 at Goldsmiths College where the artist and lecturer Michael Craig-Martin spotted his talent and persuaded Nicholas Serota, director of Tate, Norman Rosenthal, exhibitions secretary of the Royal Academy, and the former advertising man and very current art collector Charles Saatchi to come to *Freeze*, the student show Hirst organised in a disused admin block in the Docklands. From this moment, with Saatchi's patronage followed by the blessing of Jay Jopling, the dealer-director of the White Cube gallery, his reputation was secure. Best known works include *The Impossibility of Death in the Mind of Someone Living* (the shark), *Mother and Child Divided* (cow and calf each sliced in two and pickled), *Virgin Mother*, now on display in New York, and *For the Love of God*, the diamond encrusted skull sold to an anonymous investment group for £50 million, a record for a living artist.

See page 110

GRAYSON PERRY

Born 1960

Perry grew up on a housing estate in
Essex, on the outskirts of Chelmsford.
His childhood was unhappy and he
retreated into himself — he has co-
authored a moving account of the
childhood that prompted the art he
creates (*Grayson Perry: Portrait of
the Artist as a Young Girl*). Despite
this he collected nine O-levels and a
couple of A-levels from King Edward
VI School and went on to study art
in Portsmouth, where he also took a
course in pottery. He won the Turner
Prize in 2003, an experience he said
was like being let loose in a patisserie
shop. He has had solo shows at the
Garth Clark Gallery in New York,
Anthony d'Offay and Victoria Miro in
London, and Tate St. Ives.

See page 112

ACKNOWLEDGEMENTS

With acknowledgement and affection to the following:

Without Beth Elliott this book would never have happened! Apart from
being my biggest critic, she also knows where everything is in my own
cluttered studio, and what isn't always neatly filed away.

Mike McNay supplied the knowledge, the wisdom and the wit in the
writing of the profiles. We have been friends for many years and it is a
great pleasure for me to produce a book with him.

Angela Patchell, who kept plugging away when things got a bit dicey
and got it published, for which I am very grateful. This book is also
dedicated to the memory of Victor Willis, a great inspiration and friend
of Angela's.

Toby Matthews, who has done a wonderful job with the design and
kept me on track in the last few weeks before the ever-stretching
deadline finally loomed.

My great friend Maggi Hambling, always a great supporter, for keeping
my spirits up and always encouraging me with my own work and for
her foreword to this book, which talks amusingly of how we first met.

And finally, everybody at The National Portrait Gallery, especially Clare
Freestone for all her friendship over the years and her help with the
exhibition to coincide with the book.

For Rebecca, Mabel and Ben who know the truth